MIGRATION LETTERS

MIGRATION LETTERS

poems

M. NZADI KEITA

Raised Voices BEACON PRESS Boston

BEACON PRESS
Boston, Massachusetts
www.beacon.org

Beacon Press books
are published under the auspices of
the Unitarian Universalist Association of Congregations.

27 26 25 24 8 7 6 5 4 3 2 1

This book is printed on acid-free paper that meets the uncoated paper
ANSI/NISO specifications for permanence as revised in 1992.

Text design and composition by Kim Arney

Raised Voices: A poetry series established in 2021 to raise
marginalized voices and perspectives, to publish poems that
affirm progressive values and are accessible to a wide readership,
and to celebrate poetry's ability to access truth in a way
that no other form can.

*Library of Congress Cataloging-in-Publication
Data is available for this title.*
ISBN: 978-0-8070-0807-2; e-book: 978-0-8070-0808-9

Offered in honor of
my Living and Ancestral Family

———— • ————

Crafted in the Light of
Ben
Anthony
Diane
Bill
Dorinda
Tracey
Charles
Gary
Ms. Toni Morrison

CONTENTS

THAT WE HEAD TOWARD

THE IDEA
OF ANCESTRY

102.

My mother washed your weekly pile of panties
while pee tested her own body's drawstring
with a faint touch, then a nudge. She wanted
to get done, to skip the field. She wanted
to play. After she hung your drawers up
by the scant silk rim, made to catch your sweat,
she dropped her head into a quiet she could
own. This girl. Whom you called "Your Girl" or
"Your Day Girl," depending on the company—when
of course, she never was. Simply My Mother,
before Marriage-and-Children Camp. You having
a fancy moment, her having a nickel. Nobody looking
with a tilted, preordained lens at a ten-year-old female,
Negro, counting a times table. Wrapping a wish
like a grace note, like a string around her thumb,
a wish for wings. My mother squatted on the way home
after her portion of 'yes, ma'am.' Before having to make
rules and beds and trace the lines. She yanked
her own grayish cotton drawers aside to water a slope
of pine needles, far from your gaze. Far
from the shade of your house.

[FAR]

out of the bottom of ships, the ground
looks good, seems somewhat
comforting, to you.

out of the quarters, the possibility
of a shack from leftover boards
and a crop for pay appeals.

off the dirt track going round
each year, while you use
one of each thing

and none of some things
and most of nothing in full,
the train's call groans like an answer.

so that the slaughterhouses
and doctor's kitchens
and boiling steel
and butcher buckets
and shipyard toilets
look like a floor, brightly lit,
swept by a fiddler. or look
like a twenty-hour train ticket
worth a boss's glare.

your dreams stay small as the creases
of your fist. that's what
you know you can hold.

and those dreams stay where
you can imagine their temporary
heat and sputter. and live.

you will tell yourself that
is enough and it will seem true. that
is life, you say. that's
all. that's it. that's all.

[MIGRATION LETTER]

153.

Your fathers came home
haunted by stench. By Java,
where waves of copper
faces, blackened teeth, streamed from
nickel mines. Wordless wreckage.

[FATHERS]

27.

the trolleys click
like metronomes, measuring

the unconcealed prayers
of your mother
or mine; from the window
I smell their talcum
and see their houses,
calm and folded
buddhas on fat haunches
curtains waving white
as bridal gloves

bending washing
standing and ironing
swings the breasts
like a rosary
planting secret screams
deep in their mysterious laps
the soft sides of their arms
collecting steam and soap

a pendulum
of female motion
keeps the coin jar full

a wide-skirted
black dance
rustles
cloth in a
cedar chest

the reverent
feet of midwives
carry the sound

[NIGHT SHIFT/DAY SHIFT]

45.

Were the skyline and the sunset and the yard fence
 and the kitchenette and the skillet and the bean pot
 and the beauty shop ready to be tipped and drunk by you?

Were the prim church gals and blues queens, dark boys
 unloved but keen to turn those circumstances, the God-collared
 and the kind, the muted and the hunchbacks,

the perfumed, black heroes of war, black wars dressed
 as servicemen, the yellow Jesses—were they braced for their
 redemption, surely? Surely? Did they dream the arc of your

finesse, your balanced matter-of-fact? Bus-stop mahoganies,
 with glide inside their grind, elevated far from the women
 who paid them, unsung anxious fathers subject

to adjectives: you crooned above their heads, your net
 their anthem. Dark girls measured for grace by loose length
 of curl, nosy neighbor ladies, neighbor men who rise from
 filthy cots and pass on the pavement with lunch
 in a paper bag, the unstoried-unofficial, the bigly flat-foot
 eaters of ribs and lanky blue-funk gents—

who would wipe their mirror and prepare
 for your unveiling gaze?

[LIBATIONS FOR THE ONE HUNDRED YEARS OF
GWENDOLYN BROOKS: TO YOUR HEART]

Fools!—all of us,
thinking the John Henrys
were only men, when all
that while, you slung formidable
Black steel, unsilenced,
from a dining-room table,
from a small desk in a small
room where the electric
was sometimes cut off. Suspended
in a lonely love, you set out
by foot. You set out
by gang trails and trains—to read
in talk, in traces. To liquefy,
to amplify by sight. To cut
with a cue stick,
with a smoking cigarette—
to holler out an opera
plucked on our
hungry-to-be-happy
blues, our weary wings.

[LIBATIONS FOR THE ONE HUNDRED YEARS OF
GWENDOLYN BROOKS: TO YOUR JOURNEY]

173.

Squeezing fresh oranges for juice
and setting the weighted glass
pitcher to chill far back in the fridge
was worth the work. In the thirties
you stood in uniform. Spun
a metal wheel to start
the cloudy gush that cranked
to bee-yellow pulp for those extra
children you gave a folded
smile, whose parents paid
you in torn blouses. Envelopes
of pennies and dimes.
Dumb-beautiful,
we came bobbing to life
in the fifties, called down
your rough-carpeted
green stairs
to a world wrung
right: that single
love-bright morning note
you poured in small
delicate glasses.

[MIGRATION LETTER]

69.

When you jumped out that
Birmingham window, you bit
down on daring.
Learned to spit. Capsize squeamish
words. Untied hunger chewed your

seams. DeCarava's
funk-and-fabric canopy
lit your new path.
Hearing the grandmas—street-plums,
prim ramrods, hard-pressed—belt a

Southern girl's choices,
you fled the metal acres.
Leaning, leaning out,
lured to Lenox Avenue
you jumped again, unsqueamish:

Malcolm's golden eyes
spit dirt. Loved Harlem's aproned
waist. Its mottled neck
tie. Fed you heaven with black
hands. Dared you to speak.

[MENTOR AS A YOUNG WOMAN:
TANKA FOR SONIA SANCHEZ]

54.

Nat King Cole Lawd Ha'mercy fresh trout Fats Domino
Saltpork dishcloths Ivory Soap electric storm Crisco

Checkers Peanuts Dr. King Posner's *Um-Um-Um*
Stay in prayer Adam Clayton Powell Bennett College talcum

Stewed tomatoes *Have a seat* Charles Young Post Saltines
Pick up a pound of Butter. Sugar. Sweetpo. Lima Beans

Headed overseas, yeah. Morton Salt JohnLaw cold Pepsi
Avon Shiloh Dinah Shore pie crust Pearl Bailey

Cracker Jacks carfare Mr. Charlie Miss Ann
Diahann Carroll *Now, ain't that somethin'* Amen Amen

clothesline Dinah Washington Fish fry Camay
press-n-curl down home Miz Nettie Harry Belafonte

Patti Page change purse Raylettes Johnny Mathis
Co' Cola Yellow Pages Clorox Sunrise Service

Comet-Cleanser marmalade Miss Mabel collard greens
drumstick Grace Kelly Morris Brown College starch an' steam

Sunday Tribune Heavenly Father ice box Moms Mabley
Ebony Magazine gypsy cab Mr. Ben John Kennedy

Easter ham Junior Choir sweet corn Women's Day
Little Richard Sam Cooke PTC Mayor Tate

Tindley Temple Mass Choir *You Better Hush That Fuss*
homerun *Ed Sullivan's on* Cousin Cora applesauce

RCA-Victor Billy Graham Aunt Jemima CapeMay
Get the door Candied sweets God Bless That Sidney Poitier!

[A HOUSE FULL]

195.

florals by the fist—
your insistent wallpaper
resembles extra
pleasantries, calls truce to these
rooms in working-class portions

fatback squeezes down
your flowering stems, your fear
—enough to fill a
second freezer, doors and shoes
saved in a moldy basement

with hearts unable
to resist your flaming guts
with grease unable
to say what each hungers for
you resist your burning lungs

[MIGRATION LETTER]

7.

 Humming what you heard leak from a Belfield
 Avenue bar on the midnight walk home
 with your aunt from the hospital kitchen

White lines on black streets mark your expectations; bus exits, orderly
 without dividing signs
Formless lines strung between hatchet eyes and mouths, authorized
Black lines recognizable only at night, by a speakeasy singer's faint scent

 Whistling you sparked outside the Bandbox
 on a summer night with Mildred
 from soldiers lighting cigarettes at the trolley

Troop lines under Southerners' withering inspections
Clotheslines, dependent on poles, clang unrepentant
 in Philadelphia spring
Squat lines of collards in a patch of yard nod to clean shirts, dangling

 Deep-kissing you and Piggy witnessed, riding
 the bus after caroling at church: two figures
 in the alley at Pulaski Street

Color guard lines, three by three, hip swish off your flaunted flag
Gutter lines where you reset pins in an alley but must eat lunch
 out back
Ticket lines at the Orpheum lead you climbing carmine
 velvet to a golden roof

 Chuckling, you rolled off Lipsi's back steps
 on Wakefield after pouring cement
 newly drunk on chianti

[OUR DAY WILL COME: SEASONS]

We landed—new North Stars—in unrelenting
hours of a continuous, flickering night, whether
we spiraled quick or lolled, ambled or
fretted. Between snaps from the Brownie camera
damp clothes and Nat Cole lyrics. Rug
remnants, matched, nailed over old linoleum. You
paused a snatch, to take in our

meanings. An inventory over time: who cracked
plates, who sang windows open, who jostled
devilment, climbed bannisters, turned blue, rebelled, no
matter. If the lottery of birth showed
holes, you could make jokes, borrow supposes
or beg grace. After each christening—stricken,
fearless—you drew back the coverlet on

a pair of velvet cheeks, poured lashes,
rose-brown lips. Blind will, milking baby linen.
You counted out two breaths. A few
more, thinking ahead, a week or two
at a time. You counted everything. Shoestrings.
Potatoes. You counted everything you could already
see coming. Everything you could see missing.

[OUR DAY WILL COME: CHRISTENING]

You do what you can do: feed
us. Cut while you serve. Drive
wherever work opens. Pray
heat and rent and roof. Train
neatness in fingernails, in shoes. Repeat
in schoolwork, reinforce
clean speech and collars. Walk
while you drift to sleep. Drill
church in, not down. Freeze
white danger behind your teeth. Pray
that secrets drown. Save sturdy
boxes, keep sardines, candles,
a working radio. Watch
while you stand in wonder. Snap
an Easter Sunday photo. Swap
bets and card-switch to risk
a sweepstakes change; to do
what you vowed and swore.
Part faith. Part luck. Part looks.

[OUR DAY WILL COME: RUBY DEE AND
SIDNEY POITIER SAID WHAT YOU COULDN'T SAY.]

AN AGONY.
AS NOW.

129.

(1)

Tarzan follows the sound of panthers sliding. Elephants
singing at the lake, birds cruising the canopy. His weekly
journey into strangeness wipes branches back, steering
the foolish white people deeper into worlds with their guns
and teacups. Pressing forward, they bark demands when they
have no right to speak. Nothing new.

I wanted to watch your far stranger story. Leather pants.
Work boots and jingling chain of keys. Your Southern mutter
through a toothpick. Tight shirts. Eyes that squinted at
the screen door. I was real in your sad eyes. The unasked
question always sagging your lashes.

A man with a woman's name. Or a woman who made sure
every woman thing fought your muscles. Raged and banged
like the white lady did when natives burst into her hut.

(2)

Tomboy, they tossed behind girls. *Fairy,* muttered after boys.

But you were grown, far into The Life. Their hard and
busy, black-eyed un-talking must have found an extra use
for your name.

What did they call you, except Unspeakable?

(3)

Pretty and kind, friendly and overwhelmed, my mother
must've been a perfect crush. Forbidden, with two kids and
a husband away until weekends. Right next door and almost
always home. Her grip on the broom or coffee pot moving,
always keeping a line between you. The hunger I saw flick out
of you, Eleanor. The thirst for a chair and a chuckle. *What
on earth did you talk about?*

I didn't want you for a father, Eleanor, or an uncle. When you
came by to pass time, you swung your leg over the backward
chair like a cowboy. Or leaned on the counter, your gaze
prowling across my mother's faintly rigid back. I just wanted
to pose on the sofa: good girl, lost in a book. Good
girl, sitting in the living room to watch TV.

(4)

Hard as it was for my aunt, whose white classmates helped
themselves to her dream jobs, her degree curled
underfoot like autumn leaves stuck in dog shit?
For my uncle, who worked wartime hangars
in Japan but the Philly airport? Never. Mashed his cigarette
and hopped the back of a truck, off-loading rugs.
Hard as it was for my father, trained by Italians
in a trade no union would allow? Blunt answers
at every trailer, counter and clipboard.
How did a butch woman make a living in 1960?
Ditchdigger? Fruit picker? Grease monkey? Janitor?

(5)

You had the same ladders to climb that we all did. High above
Virginia or Georgia or Carolina. And you had others.

(6)

Who your people were. Where they came from determined
what you'd do and run to. Where you'd pray and who led the
flock. What you'd sign. And answer to. Which branch of the
service you'd join. How far you'd go to burn off
the marks. What your drink of choice would be. What
cigarettes you'd smoke. Which part of Philly you'd stay in. What
escape would mean and how long. How short the notes
would play. How keen or wide the notes would hold. And who
would hear. Who'd sound a tuneless fake. And who
would speak your name.

(7)

In 1960, Eleanor, you had to wear a dress.

(8)

I heard your people got hold of you. Found
some man and forced a marriage. I shook
my head, Eleanor. Stomach
turning, I shook my head.
How did it happen? You, in a veil
and earrings? I pictured you speeding away
on your cycle, the wind tearing that all-wrong
white skirt away from your waist. Pants
and that chunk of keys showing.

[LETTERS TO ELEANOR]

34.

Dark was supposed to mean dumb. Your first-grade
teacher knew; why didn't you? Why could you outspell
her very best stars? How did you read all that? The nerve—
the nerve of you. She'd find the stupid part. Your teacher

—she knew why. Didn't you? How could you outspell?
New ways to overturn: rip the paper red. And roar,
"the nerve of you!" She'd find the stupid part; your teacher
set that neat, clean collar blazing. That meek brown quiet.

Ways to rip the paper red. Ways to roar. Overturn
good girls your age, giggling in the bathroom,
neat, clean collars. Blazing. That meek brown—quiet.
(*What if What if What if something went wrong?*)

Good girls your age, giggling in the bathroom,
imitated the preacher, traded a comb
(*What if What if What if something went wrong?*)
—pocketed a key chain, blew up in a church. And nobody—?

. . . imitated the preacher, traded a comb . . .
Nobody. *Killed.* In jail? Nobody went to jail?
—pocketed a key chain, blew up in a church? *And nobody?—*
Girls like you. For Sundays, got hair pressed—

Nobody. No killers? No jail? Nobody. In jail.
Like you. In the kitchen, probably. Maybe at a beauty shop.
Girls . . . Like you. For Sundays, hair got pressed—
What happened. To them. What. They. What happened.

In the kitchen, probably. Like you. Maybe at a beauty shop.
They . . . you kept asking. Those faces. Blue anklets.
What happened. To them. What . . . They. What happened.
Brown eyes without water. Squeezed. Open.

Them . . . you kept asking. *Those girls. Blue anklets.*
Low voices. Cotton dresses shut the kitchen door;
brown eyes without water. Squeezed. Open.
Put you on the porch. *Where is safe? Policemen?*

Low voices. Cotton dresses said "hush." Shut the door.
Who . . . ? *Dogs would come—those wild nightmares—*
put you on the porch. *Where is safe? Not policemen!*
Cutting open crowds? Safe means running. Run—

Who. Would unleash dogs—wild nightmares—
into soft flesh and church dresses? Your father's . . . at work?
Cut open? Crowds. Running. Everyone's not safe—
What might go wrong while he's gone?

Soft church flesh. Torn. Dresses. Your father's at work—
Go play outside, your mother said.
What might go wrong while he was gone?
"Think too much! Just—go. With Lu's kids . . . to the movies—"

"Go on an' play! Stop askin', I said!" Your mother
snapped. Low voice. Tight lips. Brown arms hushed. "So smart . . .
you think too much, Girl. Go with the kids. See the movie—
Baby . . . Go on with them. Here . . . Y'all sit together, now."

[1963]

70.

Stuffed with your murders
and inherited murders,
elaborate and gut, your
machinate murders, inseminate
murders, adjudicate murders,
your remunerative murders,
your decorative killings, active
deaths, your aggregate killings, compulsive
deaths, your sublimate, dismissive
killings, deaths justified by martini,
informed by Harris tweed,
incentivized by online transfer, your ejaculate
slaughters, touchscreen swipe-kills
tax-abated genocides
murders detonated and slaughters deflected,
somehow you stand up,
insouciant, ready with Something
to Say. Crusted in fictives,
insulated from their stink. Invisibly
comforted. Invisibly proud. All
you've invented. All the behaviors
you hoard in that plaintive closet. All
you stand for arranged beside you, also proud.
Certain, and certainly alive. Alive
and deserving longevity. Posturing dismay.

[WHITE LIE]

205.

Breaking news, Grandma's little TV blurted
out. Three names. A choke knot shrunk the dining
room. The grownups froze. And you kids
noticed. "*We interrupt—*" it said. You blinked

away the first two names to better hear. Again
your grandfather's name in Walter Cronkite's
mouth: "*James Chaney . . .*" came, strong
as concrete. He jerked up from the table, straight

—as if a rope had yanked his length
of life. "*Civil rights workers, missing since . . .*"
The birthday cake began to sag,
a sickly yellow sponge.

"*Beaten to death . . .*" No, you saw him
stand. Right there, unswollen. Alive
but "*Shallow graves . . .*" got the best
of your stung eyes, no matter what.

Cronkite slow-shook his head. As if
no one saw it coming, days before. As
if no one ever heard of such. As if three
missing men, killers "*uncertain,*" was all

a mystery "*to launch a probe into—.*" Could
he mean your city? Could that dead man be your
cool young Uncle Jimmy—where was he? No,
not Mississippi. You saw him leave. Smoking

and laughing, his candle-eyed friends
had come to beep the horn and call *Yo, Chaney!*
through the screen: And that Mississippi
soul. A lost cousin? No. Someone

else's people stood round a table now, holding
open cuts. All of You, related. Chained to a room
by names. Twisted throats. Mouths closed. Mouths
hung dark, like that James, full of shapes
he can never outrun.

[NOT YOUR PHILADELPHIA: AUGUST, 1964]

107.

A war was going on, not far off. Hungry for people like you.
A growing war your parents could not shield you from
or explain when they snapped off the news,

their lips pulled wide, like scars half-scabbed. To comb
the heavy silk that passed for air, give sight to words,
tamp down your dream of werewolves, fanged without foam,

who might ride North to strangle, bomb, or prowl
 the nearby woods,
you took up the armor of Black witness: those photographs

bodies under tablecloths or coats, home
 to cumbersome wounds.

Your finger, compass moving through the Black world
 open on your lap.

[*EBONY* MAGAZINE: WAR]

You could stare without being slapped for staring
in *Ebony*, where you would learn how weeping
looked without tears. Reading the sight
of seers, you turned every page. Their pictures
pitched you into some nameless road's haunted
edge, that Pettus bridge, the torn throat of a staircase.

Finding the flash, you leaned into eyes like yours.
Eyes that expected breath to push them open,
squinting, stumbling wayward, hungry, fractious.
Onward to another hour. An obedient next
day. You almost caught their damp windbreakers,
their faint cologne under cigarettes crushed
on rocks, their sweat. Medgar and Myrlie Evers
lived in a neat, modern home that made the South
look as if they got a better deal: a split-level
on a Jackson city street that seemed suburban, except

that blood—thick as engine oil, too much for paper
towels—soaked a whole block of that driveway, steps
from the house. He almost kissed his kids. He almost
let the screen door bang. Did he grope for the rifle?
Or murmur his evening joke? You traveled. In places
that could not invent to satisfy, or sugar over. On pages
filling the shatter, written with light.

[*EBONY* MAGAZINE: TO THE PHOTOGRAPHERS]

Harlem. Horse farms. Geechee. Weavers.

Nova Scotia. Mardi Gras.

Black people, mountain climbing; hooks and gear. Black
 riders, in those odd
 hats roping, under lariat halos.
Black women, crossing Paris streets in kitten heels and scarves
 tied like a Hepburn. You wonder—what would they eat
 in France? Who does their hair?

The question stretches to those ads in back: *Want Long, Silky*
 Waves? Manageable Hair Overnight. Growth Miracles!
Could be they tried those potions before stepping on a plane

 without a Thelma, Della, or an Ernestine to test
 the perm. Or packed one of those small-print
 back-page wigs.

Dunham. Primus. Med school. Ghana.

Canada. Panama. Seminole. Skis.

Brazilians, speaking Portuguese. Afro-Germans. Afro-Cubans.
 Manicurist to the stars. And not all yellow. Lives
 that seem made-up. Or out of reach.

Sculptors. Swim clubs. Eleo Pomare. Nadinola?

A ten-year-old romantic, you crave the World. But is it safe?
 And still, and still; you cling to marvels.

[*EBONY* MAGAZINE: DIASPORA]

156.

You learned your mother's body could be touched
with metal bearing a serrated edge.
Classified. Speculated upon with leisure,
with a watery zeal that looked
like tears. Quantified.
Granulated between two fingers
And two more. And.
Masticated. Milked. Embossed
with brickface or patterns
of spring roses on satin.
Prancing seahorses
or jonquils gaily tied
on the scarf
gagging her mouth.

[TONI MORRISON KNOWS]

74.

Newspaper glued together with cheap paint
and blood. Whiskied hope and incivility. Milk

carton crushed by the H bus or a Nissan
Maxima. Water bottle, soda bottle, KFC

bag. Bones murmur in a 2-piece box
the pigeons missed, distracted by pizza

or an open can. Soda bottle, soda bottle,
MickeyD cup. Damp shroud of Jesus. Muddy

and rain-washed, thing looks like a T-shirt
somebody hung on a stop sign. Industrial

sludge and wood gone soft under the shingles
Big Momma paid her nephews to come fix.

Under the swollen trim. Under the plaster
cracking brown in her back room. Sugar weather

rolled in over the rot. Everything changed. Eugene's son
set the trowel down. Never finished. Dropped

out of OIC. Among the missing. Door half-closed to cool
the mood at Walt's Devil Island Lounge. Lyric chatter

spilling out. Spilling out. Lyric-coated sidewalk
rupture. Sidewalk, underfoot of men, grown

past the rituals they know. Men carving
their own crucifixes out of incidentals. How

do they wheel their shame along
the precipice where fearful pressure

melted better ideas? Women who pass
by, wiping a finger. Women narrating hair

shop -fist knot- lingerie sales. Home work
-late shift- rented room. Loaning and laying

away. Standing over the dark stir of pots. How
do they complete and comply? How do they

translate the paperwork? Submission of all
requisite forms? Cement steps eaten away. Dead

factories churn the milk of heaven
through busted windows. Politicians call it

blight when they're readying to capture
the scraps. Soda bottle, Wine & Spirits, plywood

plank. Post-Alabama. Post-Carolina. Autumn
afternoons without clouds ordain these descendants

of farmers. What do they tally and yield? What
is that, moving the blank eyes of three-story caverns?

[16TH AND ERIE]

105.

Too much world had scored, creased, split
your back. By 1989, you'd been bested. The slashes
sewed together with a rope-scar.

Hardly anyone left alive would consider
that you even owned a vagina. Or imagine the red
syrup draining from you. The man of that

house and his saw of a penis—dust
of imagined dust by then. The splattered
floor. The apron you balled up, quick, to wipe

yourself—stuffed in a kindling bucket—
caught flame slow. That apron climbed
up the smoke to die in twilight

Georgia air. Ash fed to a flower garden
by your trembling left hand. That
shoreline of a sink dug into your shoulder

where his ruddy-red claws grabbed hold
to trap you, away from the hall. That sink
where you rested to cut apples. To watch

color slip down the pantry curtain. Slip like
you, in 1937. Trying to faint. Shuttered, unlocked.
Unlabeled. Boxes of moldy years ago.

[BY 1989]

9.

every flower cars whipped past on a two-lane road
every flower trains curled to straw under their iron gullets
every flower mashed in shitty ruts by a wagon, hauling
 children yanked from school to pluck some
 fat proviso in unmarked fields: You, singers.
 You swelled them all to witness, in your guts
 your throats, your vessels.

sheets of percale and rust and rattle
sheets of satin and raped magnolia
sheets of reveille, trilled by Alabama swans: You, singers.
 You. Sang Georgia out of its secret graves. Let
 the drunk brother gather himself on the back
 steps and say his piece. Smuggled rope
 out of Mississippi, braided like mist.

Now who will call the patterns out in names we invented
from rough fabrics, born for bandages? Who will assure
the elders all have rides home? Who will secure
the night outside their doors? You, singers, knew
 where the cotton cut, between index
 and thumb. You called out trouble to come
 eat salt tomatoes and laugh across the street.

Now here our young come: blue-lit and bleary, out of black
Challengers on circus rims, intent on screaming, out of screens
intended to suck them blind, plugged mute. We wave, we lean
from the porch, out of ways to transmit or maintain.
 Who will wade out, rowing to that place, just
 beyond, where procrastinated dying trembles
 in living creases? Begs a dollar to pump our gas?

Now that you're gone, whose rusty tenors, whose whiskey
altos will straddle these tides? Who will work the night?
Season the skillet? Keep the watch and hold the subway gate?
Who will walk the wretched up to the altar?

[LETTER TO THE SOUL SINGERS: LOU RAWLS,
ARETHA FRANKLIN, KOKO TAYLOR, RUTH BROWN,
BROOK BENTON, NINA SIMONE, B.B. KING, OTIS REDDING
& JAMES THE-GODFATHER-OF-SOUL BROWN]

THAT WE
HEAD TOWARD

111.

The bell rings, the whistle blows, the order blares to stand
 "Quiet. Perfectly Still and Quiet." Doll-eyed white girls
 time the throw of their hair: here comes a bomb of static
 thread to sting your eyes and slice your mouth that goes
 unseen, but not unsmirked, until you cock an arm to whip
 it back where it belongs.

Here comes up-close and blue-eyed-pink-finger-pointed
 scolding. As if afternoon math won't bring dread enough.
 Now charged and convicted of "taking up everybody's
 time," you're sentenced to a shoulder-yank out of line—
 since somehow, you can't understand "Quiet. Perfectly
 Still." Although you're that little monkey who can read.
 Somehow.

[LETTERS TO BLACK BODIES: INTEGRATED MORNING]

Mad at Dr. King all the time, you learn to study
 distance, weight and volume,
measuring the time to hand-raise for the bathroom
measuring the time to hand-raise for an answer you know

folding, folding, words all day, pinching
water in your ducts and channels, calculating
the drifts and whims of teachers you're watching
 for human signals

observing the sides of Jewish boys' faces who lean
to numbers like you soak the fragrance of words.
Counting time until the blessed bell's benediction
 —one more day of a thousand

in this mine shaft, or cotton field, or yammering
factory of shoes and teeth and coats, multiplying
by smells, dividing by that horde of loud
 or gummy, numb or nosy white kids

—subtracting exactly two from those who'll go
changeling in the coat room—even the 'nice'
ones, milkweed-dreamy, joining the fun of trip-
 and-push, "so-sorry," coat-hook jabs

to your arm on the march-through, then lunging
at the line to avoid coming after you. Front makes them
giddy; they learn first is right. You gladly take caboose, free
 from the piss-boy's scrawny black

neck, free to anchor space. If he goes last, you're forced
 to feel his body's dirty cloud rising,
leering, weird as an extra shadow. Better that twitchy
Polish kid than you. *Go on,* you wave and hang back,
half-smiling when that trick works.

[LETTERS TO BLACK BODIES: INTEGRATED AFTERNOON]

For the Rope Gang: Muriel Allen. Monique Austin. Beverly Perry.
Gwen Watson. Iva Watkins. Johanna Jones. Sarah Gibbs.
Donna Rowe. Emma Jones. Linda Clary.

Each of you heard slights
mused, muttered, slurred. Repeated
by kids, by adults.
In your double helix, spun
a home; your tough legs worked spells.

[LETTERS TO BLACK BODIES:
BLUE PLASTIC CLOTHESLINE]

You don't have to be tall or muscular. You
actually don't have to be cute. Or light.
Your shape might have some boxy
goin' on. Might be a few thigh
rolls past healthy. You do not
need a car. That hot pink top
from Marianne's, which you would have killed
in with five more dollars, isn't crucial.
Clean, a must, smelling good, yeah.
If you actually can't catch a beat, just
wait. The needle's bout to drop, crackle, lick
that black liquid pool. Swim
toward the label on a wave
of Funk so thick you'll ride for free. So what
you ain't got a hand
to grab. Once "Fence Walk" hits, the floor
is all moves and hair. How
fortunate are you? Let that hurt slide
out and just dance. You're a four-minute
Guest of Honor at a sound
spa. You're ringing a bell
at the Funk Gates of Oz.
To land in the world
when Funk buys
a house in your body
and renovates every six minutes?
Ain't you ready to pounce
when Funk anoints your flushing
senses, twirling
your hips with the dee-lish? Just.
Dance. Disco will soon put all this
on life support. But you don't
know that yet.

[LETTERS TO BLACK BODIES: "FENCE WALK"]

25.

They knew the World expected You low. Wanted You
inappropriate and dirty. Trained up right, You would pop
the World's padlocks, punctuate

its longings. Despite what They said, They knew
how *that* World *did* love You: Loud.
Crooked, clouded, announcing. Unable to rule

over tenses, untidy tongue mumbling. Once caught
in the spotlight, incomplete. Or pure
mute. Oh, They knew where trip lines

waited. What indifferent signs—blades, barrels—
might explode. Or come speeding. Their opposite
joy, the harvest of Their being, came from

sending You out. Ironed fronts, backs,
underarms, hems. Not only washed but starched;
ordered. They'd bark "*Speak clearly and distinctly.*"

Shined, heels never run-over. Fresh hair,
cut, pressed, or shaped. Wordless, They folded
a laugh once You crossed the doorway

Their steady commentary: You. Beamingly
blessed, smart and lucky. Prayers, the silent
molecules, bound up in every chuckle

Smiling, They spit back and traded
glances. Stuffing the sight of You down
nattering throats. Choking the world of white.

[PRESENTABLE]

11.

Raisin in the Sun playing on the TV all those
years. In all those viewings, Ruth Younger, yours

the testimony of the nearly-dead. Muffled in story, in
service. Your ironing, endless. Standing sideways,

on the side. A splinter in the palm of pain. Clawing up
the hips and waist of Ruby Dee's apron—your hands.

Squeezing out of her—your dashed delirium.
You liquefy the granite in her eyes and pour.

Ruby plays you like a shattered fist—all knuckles, bared
and tucked. Snatches what you touch,

slaps what gets too close, knots the drawstring.
Words flee her mouth, words hex it shut.

Ruby rattles when you hit the floor. Nobody knows
like you need them to. Everybody does.

After that momentous move, kids puff your veins. And eat.
Bennie taxies on a runway, somewhere; Mama's gone.

And Walter? Driving and driving—still—spinning
into the dark dawn on a west-side bus.

We imagine Ruby spins your pretty kitchen,
but fires outside don't quit. Hose water don't give out.

Beyond your well-scrubbed door, Good People plan
their fears. Who hears the goodly snarl—and deny?

Walter ain't got what you're digging for in that purse.
How long, Ruth, to buy your own inheritance?

All these years. What waited? You, again—
we imagine. Standing at that Clybourne bus stop,

a sharp-edged rock bobs in your pocket. Thanks to Travis.
We will snuff their torches, Ruth. We'll wait with you.

[THE HANSBERRY SUITE: AFTERWORD TO RUTH]

Oh, Freedom! From sour sweat. Canvas sneakers
 on unwashed feet.
Oh, Freedom! From everybody's salt-pork
 collard tureen

the iron-rich redeemer, multiplied by five
 thin floors,
by pig feet nastiness, killing spring's leisure
 at the door.

No creak of metal mailboxes; no
 vestibule hallway
no hard tangle of talcum, sweet
 potatoes, aftershave.

Lingering at your historic door, you handle
 those keys
to outwait your neighbor, crouched by the sill.
 His hidden steel

mouth jeers. His lobster neck cranes as if he spies
 some tie-less
stranger. You spit that rapier
 name: Willie Harris.

First house you've ever lived in lands your side
 glance on a blaze
of new smells. Geraniums. Forsythia,
 making praise.

First backyard. Basement. Garden hose. Space.
 Before that, you got
Wife-smiles. First sight of Travis, snoring
 in bed. First tool box.

[THE HANSBERRY SUITE: AFTERWORD TO WALTER LEE]

Birds. They treat you, calm you, warn, alert
to what you can't hear now. Bus, groaning to a stop. El train's
dim rattle, blocks away. Basketballs gasping

off the asphalt, whomping and springing. Do they snatch
an extra breath from anyone half looking, when they fly
past expectation and boomerang

that catch? Or does the air split its throat open
and sing? Front-window neighbor lady cackling. "*Ain't that
the truth? Lawd, they don't know the half.*"

Fish man chanting what's good today, cruising in his saggy
car, over his whiny engine. Are all the kids on punishment?
You ask Aunt Bennie. Even though you know.

You see them slip out of their side doors and hot-foot
down the alley, the rope of them tied
together with one grin. A dog barks twice, whines once

and stops; you hear it. Forget alley cats. Once a metal
trash can kicked itself off the back
steps of a house two doors down. You heard that too.

No one out on the porch but screen
doors slam when you pass. No one to fall in with and race
to the corner? No one to call your name on the way?

Two men at a fence on one side. Three
on the other. Red scalps showing through their hair look
like peeled-off scabs. Only one of them talking,

low. Like the preacher, spilling out a mutter-prayer
that turned your neck to a dangling rope one time. Your head
snapped. And Grandma popped your knee.

Rocks in a pile under a bridge by the bus stop. Perfect
sized: the kind you might need, locked
in one hand. Sharp-edged. They don't ping. They chunk.

Five white men pass something across the fence
in a box. Same box the next-door lady left
on the steps, back when Grandma was alive. You opened it

with a stick. The day you circled back and stayed home
to listen. That box turned up
again in the trash with a whole cake still inside.

Five old white men. Slick heads, almost touching.
Praying something, something evil. Evil
as a flat bird beside a bloody hammer.

[THE HANSBERRY SUITE: AFTERWORD TO TRAVIS]

Those white girls at college pretend
they don't see you so hard, they get
to believing you really are a tree
trunk they can lean on. One sat
on you outside the registrar's office
as if you were the chair; imagine
the arrogance. Claiming, with a red
tipped index, not to notice. Sounding
like you were the accident. So you made
the library basement your own. Near
the boiler room door, furnace restarting
every hour, that cackle and knock
shimmied up the pipes. Boom after boom
heat landed with a rhythm,
like Olatunji's "Drums of Passion."
That pattern fixed your mind and while
you don't believe in signs, you gave
your best work birth that season. One
semester later, a fellowship: Paris—
where you would bawl on a barstool
as a witness to God, pouring down
the barrel of Dexter Gordon's sax.

[THE HANSBERRY SUITE:
BENEATHA WRITES TO HERSELF]

57.

You don't wanna let them holes
get started, naw no. Next thing
you know, mess gets out, rippin
what you mean to keep
neat or in best shape
an runnin ruin where you spent
half of life tryna keep clean. You bent
over, takin on them heavy
consequences. Mess grows
from a hole. Hear me? Mess.
Ain't talkin just to be makin
noise. Plug it, patch it. Don't
care how. Stitch them holes
up. If you done ripped
your church dress or good shirt
throw a jacket on. Cut
yourself, take and run
some me'curichrome
up in there or *Campho*
til you can see somebody. Say
the wrong thing, well. Common
sense'll tell ya, shut that mouth
of yours an stop the leak. Wrap
a oiled rag around a bad pipe.
Got somebody who can help
well. Don't be whinin. Pick
up the damn phone. Worse come
to worser, run out the front door.

Sayin all that to say, you gotta *Act*.
Hole in somethin only gonna grow.
Ain't gonna fix itself. See
if what I say ain't so.

[HOLES]

85.

Before anti-crime
lights, night meant a black sky; you
stood, hidden under
velvet summer trees, calling
us, birdlike. Whistling, *Come in*.

[EUNICE ON 194TH]

6.

Road unrolls like a bandage as you stand on the bridge
over industry, factory, lumber. Machines ride the lap

of the land, gouging and rearing up. World of copper
and steel dominion, world of men.

Rust, the source of your road. Rust in thick cotton
work pants, rust serving every place you've worked.

Do you come to witness burial? Or is a harvest
barreling toward you out of dirt?

Can you make good, knotted in a fist of Portuguese
as if you're one of them? All the past subtracted

but your skin? Knowledge spins like train wheels, charging
North. Do you know you make this town a city?

How is it that even here in Norristown, bold blondes pose
at the ruddy rim of caution, seeking out the flint

of working men? Clearly, you are still brown in winter,
you are married, and yet they step, willing, in your path.

Every change, every avenue upends your sense
of earth but leaves no sprawling clue. The whole sky's open.

Each Saturday you return to scrape the top off their
noise. Bleed dirt from your pockets, dream of fruit

inside her. Ruffles hold her wants in place with pins, her
sky blue jewelry, boxed. Unstrung. A single

film plays on your private TV while she talks.
Is there balm in your gift of solitude?

Newspapers and beef gravy on mashed, with fresh
string beans. By Sunday night your TV clouds

the picture. Your cotton contract worn. Do you
return to praise abandonment?

Seated at the table this way, does the sight of four
small heads catalyze your wound, or sweeten

exile? All that gave mysterious birth when you signed
your name. When you signed your name.

Do you drive all weekend, eyes hushed open, seeking
cranes and towers, seeking haven,

to find your mark on blueprints, your word
on the shovel blade, your peace
in churning wheels
and rented rooms?

[NORRISTOWN]

13.

Here you come: Low-Country's grandkids, off
the H bus in a tumble. Feet reeling you into
your first Mall. Eyes quietly amok in the commerce
of Now. Every slick kool-created
plastic, every poured glass Thing
aims its own light. Stores sell sunglasses
with changeable lenses. 'It's a snap!'
Blue ocean streets. Sea-green almost-suburban

roofs in a tidy world turned tangerine.
Cows, cut to neat patties, sizzle on seeded
buns. Breaded chicken pieces, greasy
gold on a plastic tray. Field
after field of acetate and polyester clothes slide
into glittery bags, so unlike what comes from thrift
shops: whiffy, in refolded bags that held
groceries. All you can fit in, for a $5 bill. Needing
another wash and a starch iron.

Under the influence, your pre-teen delegation begins
to part company with the South. From this distance,
you can see the old ones back home, on the porch.
You can afford a tooth suck. Once the rising
tide of stuff sweeps in, you begin to feel in a language
they can't decipher. It swims around you
at the bus stop. You can laugh
at stuff they don't understand. You can talk
another kind of talk. 'It's a snap!' Aqua-pink
and lemon-yellow. $6.99. $9.99 $12.99.

[KORVETTE'S, 1967]

16.

Your mom practices
To greet your new aunt. White skinned.
Not pink. Girl-sized. Black
hair. A grown-up cigarette
tightens her wordless red lips.

Everyone's fumbling
Japanese sounds: "Oh-hi-yo."
Her black vanity
has a tempting chair, too small
for you, painted with pink birds.

[KIMIKO, 1961]

109.

When you left for college, you waved back
 to grandparents who had raised crops
 on land they didn't own. Cooked
 food they couldn't buy
 from any store. Cut, mopped,
 and scoured, brushed, stewed,
 and decorated cakes
 in kitchens she entered according
 to the side door–only rule. Labored
 in saw mills, hauling whatever tipped
 him closest to risk. Nosefuls of heavy
 dangers, iron work. Never designed
 to pay enough for savings. For smiling.
 For clean favor in the shade.

[GREAT MIGRATION PENTIMENTO: PERRY COUNTY]

When your father drove you to college, he thought back
 to shore leave. Whiskey on Guam. And how
 his buddies got it. Smirking master sergeants
 packing jimcrow jaws. Taught by lumpy
 South Pacific bunks. Tested by gray flesh
 and bile. Graded by fistfights and poker
 games. Expelled by MPs. No curlicued
 paper at that time existed, boasting high school
 diploma over his name. Armfuls of raw
 blisters, stone work. Choked soil,
 unfiltered clay. Never seasoned to reap
 full membership. Or trust in trade.
 Fated never to play college ball, he ignored
 the team boys offering jovial help
 at the curb. Your panic. His awe. Insistent,
 he shouldered your trunk, from car to closet.

[GREAT MIGRATION PENTIMENTO: MIKE]

When your mother waved you off to college, she shrank back
　　to Saturday nights in Atlantic City. Chicken Bone
　　Beach, heels in hand. Traveling to her sisters'
　　in Chester, the Bronx. Whooping at Woodside
　　Park. Peg Leg Bates' place, upstate
　　New York. Southside Chicago,
　　maid-of-honoring her best girl. Uniformed
　　in Margate, small white hands, right
　　and left, clutching hers. Troop train
　　from Georgia, 1943. So few places summed
　　her up, classroom to bus doors
　　to vacuum. No curlicued claim to upward
　　bound credits. No classes. No dates
　　with Memphis lawyers. Her diploma pointed
　　outward: shorthand—maybe. Receptionist
　　absolutely—"just not quite right" for her.
　　Understudy for downtown retail, she sparkled
　　counters overmuch. Jitterbugged
　　up to the Sabbath day of praise.
　　Circulator of the borrowed bassinet,
　　snowsuit, sandbox. Cupfuls
　　of Clorox. Spotty clerical work. Never
　　permitted to shine without grope
　　or glare. Your witness. Her rally: that smile,
　　enough to swing Avon. Make food.
　　Make room. Mark homework.

[GREAT MIGRATION PENTIMENTO: JO]

When you entered Stetson Hall at college, you pushed back
 a blue open door. You knew the words to lots of songs,
 but never heard of Whist. Carried a cassette player
 and a Korvette's radio like gifts for the Christ child.
 Dragged in two pleather suitcases—sky-blue; plants
 in liquor store boxes. Eked out a dumb-anxious
 smile to a girl with the same key and letter, tucked
 in her jeans. A Jersey girl—with a doctor father
 and a stereo: turntable, receiver and speakers, tape
 and radio. Hung up a cloth coat, aqua, beside
 the rabbit-collar leather on the door. Polyester
 coverlet sneaked a gaze at Glen Plaid. Terrycloth
 robe scrutinized velour. You two would skid
 from dare to skank to rescue. Issuing weekly
 vows of *never again*. Turn 344 into beauty
 hall-confessional. Study parlor. Box
 of hilarity. Enter parties sideways
 like Ohio Players, singing "Fire!" Set
 more than one. Stomp out a few
 with howls the moon found
 amusing. But you didn't know that yet.

[GREAT MIGRATION PENTIMENTO: STETSON EAST]

When you met the city you picked for college, you sucked back
 that leather pose. Hunkered in black New
 England wool. Set off on muddy migration
 for territory yet to be bordered or named. Your only
 crops were kinky hair and rage that gagged
 on paper, unfolded in books. Plowing on, you faced
 the gray weeks. Earfuls of caution, mental
 work. Packed the emergency stash.
 Copied documents, bookbag and purse, to
 prove your place. Your place. Stood up
 by Smokey, bored by R&B, you took
 comfort in costumery: Bette Davis deco
 on top, Betty Davis fringe
 on bottom. Santana tattooed
 on your pulse. Blue Mary
 Quant nails on sale. Nyro and Joni—
 the lamps you clicked, to glisten
 by a window. Nina and Flack
 latched to your waist. Socially
 situated to detonate the either /or.
 Perplexed the frat fellas who
 thought, surely, women
 had to be yellow, at least—
 or a little rich, to be
 siddity. Acted like you didn't
 know no better.

[GREAT MIGRATION PENTIMENTO: SIDDITY]

86.

Each of us, oldest
sisters—subject to pensive
winds. Scattered riches.
We understood poems lured from
blisters, shacks, lilies, and hymns.

[EUNICE BY HEART]

99.

Punch bowls of potato salad squat on a tablecloth the fan
keeps billowing to remind you there's a bride nearby. *Will they
kiss?* A whole wedding in a living room, not big, completely
ordinary. Folding chairs on both sides, the rickety church

basement kind, with slats that pinch. Two small boys peek
from a closet under the steps. A dressed-up baby rides
in on a shirtsleeve, black Mary Janes dangling. Already whining
and squirming when the old ladies chirp. Already, two sofas

packed with them. A baggy tan suit steadies the elbow
of a pink dress, blooming across the porch. *Why won't
they take the plastic off the sofa? Why won't the people
stop coming?* Your mother assigns a tray to your idle

hands. Deviled eggs. *They'll go too fast.* Those aluminum pans
got you salivating. You catch their savory volume at a glance,
without seeing a wing. A big chair you liked sitting in, gone
from the front window. Now the preacher's there, handling

his black Bible. Sweating and nodding at a woman with much
to say. *Why here, without enough seats? Why not church?*
The dining room is all lemon-scented furniture polish, table
along the wall. *No bride.* The kitchen, small as a bathroom, full

of pans and grandmas, sweating out their curl. *Don't weddings come
with music?* A little girl making a flower path from the shining
prize in white to the prince in black, you thought. *The bride
can't make an entrance. Where will she walk?* After egg duty,

your reward waits for claim: an open six-inch spot of wall
in the archway. Right of the living room, left of the card
table near that glass cylinder of lemonade. You backward
slide, letting an auntie wobble by to greet the kitchen crew

and stick it. An ideal view. Froggy Glasses on the plastic-
covered couch tries to wave you off, but you smile-stare.
You are eleven. Ready to see how *In-Love* looks. *How do lips
cling—for real?* A stiff woman passes the clackety chairs—

Sunday School teacher's pursed lips, white
netting the toes of her shoes. Her white glove
points upstairs. Somebody's shaky hand has plunked
the needle down too hard. "I Pledge My Love"

rips out of the speakers above the door. Out pop
those grinning boys. A cologne whoosh reminds
you: *here's the groom!* He has come to stand beside
the preacher. Hazel eyes gone dark. The hands you find

so sexy gripped together. You are eleven. Ready
to wonder what honeymoon means between those
hands. Ready to dress your mind in flowing gauze
like the bannister. Peaches and Herb start over

but not loud enough this time. Too low
to cover the creaking wooden steps under those
glittery white shoes, leading two brown
legs forward and down. Forward and down.

[HOUSE WEDDING]

HOMECOMING

29.

whose prayer is this
painted over ghost words

who's got the keys
to these blind windows

who can see simply because of sight

what if I see myself
scrap iron waiting for a red light

the world passing me by
without comment

which burdens
will fix me

which ones will I
set down

what do you make
of me in the mirror now
on my way somewhere

[GREEN SHADES OUTSIDE THE TROPICORO BAR]

38.

Philadelphia. The conductor finally calls.
Up the aisle to the altar, marrying
the iron crank, the sliding bolts, you plight
your troth to a metal door slowing its run, to sunlight
kissing the city side of that filthy window. Fear
makes a rock of each foot, each elbow, and most of all
your tongue, refusing to confirm. Stir; stir,
stir. Loose thoughts blur your changing name
until your children gather your vow, whole
in their eyes, and those eyes speak in unison.
Three deep steps. You seem to raise
as each one carries you down.

You are not front-pew people whose eyes
flip on their own light when they hear "Spelman." "Morehouse."
"Bennett College." You are people without tassels. Saving
coffee cans and thumb tacks, glass jars
for drippings. Wiping aluminum foil clean.

You chicken feeders, running cool patches of field
that bring you home in time, you are people without watches.

Cooking people. Cleaning people. Maybe
factory people, depending on where
you came from. Book-and-college
people, people with land, consume you
in a glow. With a dipped glance, you regard
them, as if you have reason for shame.

You cut your feet. You burn your palms.
Slit your shoulders on the loose metal belt of a barrel.
Disordered flesh expected to keep calm
through your escape from writhing red ditches and rusted
hooks meant for hog hanging.

Philadelphia. A place with a Negro
newspaper. Marian Anderson
and a Negro YMCA. With great
stone churches you will buy, nickels at a time, once
the white people sell cheap and flee
to green valleys, past the city
line. Safe for them.

You are not people on a porch, moving
fans across charmed skin. No.
People who scramble to your feet. Footsteps
that clean the city's dirt.
The cool undersides of houses well up
in the tales your children hear.
You carry while you climb.

You push the cart into line. Set down chicken livers and roast
beef, sliced and fallen, damp and holy, from a half-moon
metal blade. Onto a paper, folded and taped.

Turn at the grocer's glass case
from all you know of cows and stems.
All you know of pantry hush and potato leaf and butter science
percolates in your chest; it will stay, unless the produce man
speaks. And your South turns out to be his South, too.
Out of two words, such smiles come.

Fixed to the underside of every mailbag you pack, every bleach
bucket, a thought in half-legible ink: the North-born
young will have clear paths to front doors, presentable,
whatever they head toward. Pass Mister Charley
on the sidewalk without folding. Without stepping
off. Whatever they raise eyes to do, the wish
will tap against some folding money
in a decent purse or wallet. Speaking
paper English, easy as they want, but never losing you.

Leaf-revealing, cloud-detecting, you
drag knowledge and senses
across us, even in sleep.

You smuggle out the hymns and names of people
 worth keeping alive.
On the phone your talk trades long hmmms and high
 unh-huhs. Grunts chopped
with a dull axe, furnace-bound.

You talk to each other above our heads. Saying "LaGrange"
or "Manchester." Saying "Maydee Street" with fond, fierce
light ricocheting. Triumph, once you could turn
to look at the straw and gristle and hail
of tears and seams ripped from scrubbing. Once
you'd climbed up. And something else— guilt?
dispute?— you won't say, in front of us. Hanging
shapes of words, drained of color.

Over a second piece of Grandma's pie you set out bits of news
like mints in a glass bowl, to be unwrapped once
children go to bed. A quilt of sounds inadequate
to snuggle under for those who never rode that northbound train.
Buster. Maggie Lena. Willie Mae. Grandpa John. Mr. Blige.
No last names, no photographs.

Your dropped heads sing danger, like storms
overtaking sunshine. Training us
to sweep all surfaces with the inside Self. Little
of this comes from your mouths; no answers
that stretch to the corners. You sicken, you sink,
you pray the weight back up into thinning
vessels and cartilage, thinking
you have to hold it all, thinking secrets are best.

While pulling the bus cord, you watch for signs of the dead—
 not banished but tethered at a distance.
 Hushed in your arthritic creases.

You push the cart into line, certain of what you will tell
 those children who take their mindless rescue from a pot
 of collard greens or kale.

Your snickering children, who sugar their cornbread.
 Hide from the smell of buttermilk.

[MIGRATION LETTER]

75

213.

Your close-trimmed kinky hair, church shoes, well-ironed
 shirt and V-neck sweater only showed you were a boy. One
 who would make a mess of those clothes, playing football
 at recess. A transfer. Or a boy from across the district, key
 swinging from a neck string.

A boy in a world made mostly for white girls. And certain
 rakish types of Hardy Boy extraction. Or any child
 from the East Mt. Airy rich. You and I, Melvin, fit
 with none of those. And you? A Black boy. Unconvicted.
 Unprepared for Miss Rogers of the Nazi
 pompadour. For Black organza, and fangs.

No day in Room 209 began until you had been properly
 clubbed. Scream-cleaned and shoved
 toward a corner. Forget trouble with fractions. You
 left your pencil or it lost its point, Hitler forbid.
 Acetylene gazes would set the room
 alight. Gasoline tongue, shooting out.

Did you lean across the aisle, Melvin? I'm sure
 you did, to infiltrate my terror. Test
 my bacon-grease solidarity
 with a side grin. Did you know
 that when she squashed
 your jokey calm, she hurt me too?

Didn't I slide my half-collaborator eyes your way
 to beg you *quiet, quiet*? Didn't I drop
 and roll you the pencil
 under my foot?

Am I right that Rogers hooked her ghost-bones
 to your collar? You wouldn't let her
 yank you off your feet. And took the chance
 of snapping it back down. Did I see
 my brother's ache in your bright expression?

How many times, on our behalf, did I pinch the clouds—
 pleading for Glinda the Good Witch to ride in and set
 that bubble of hers down on the red schoolyard?
 No note descended, either, from on High, although I
 asked for a missive to drift through the window,
 to plummet on her desk ["Butler simply
 turned his head . . . He's innocent . . .
 release him. Or else. Sincerely, God"].

We could've dug a Mau Mau pit of spears. Like they
 did in that Sidney Poitier movie. We could've lured
 her to the forest with a lie—and pushed. We could've
 understood each other better. Could we have dug
 a tunnel through our minds? Those kind of friendships
 didn't happen then. Could we have stopped
 your shoulder slump? Fists in the air didn't happen
 then. I was no good at reading 4th grade boys. You
 were no good at sitting still.

Our families sat back, Melvin. Nervously. Glad. Thinking
 they had opened the right door. Pushed us clear
 of nooses. Past the soul-stripped harms
 they understood. Thought they had saved
 us. And they did. But real blades found us

in that greener grass. Melvin. Did we try
to hazard all that buttoned-up white storm?
Were we something like those Alabama
kids on TV, or not at all? Weren't
we, like them, straining to clasp hands?
Fur, fury, and even water, trained to murder us?

[LETTER TO MELVIN BUTLER, 1965]

233.

"What most people do not know, and what Perkiss presents here in rich detail, are the nuances and knotty complications that characterized the inception and development of an intentionally integrated neighborhood."

—PHYLLIS PALMER, reviewing
Making Good Neighbors by Abigail Perkiss

(1)

When the North Philly girls at work pushed up one eyebrow and the West Philly girls at school (cooler than Cool itself) sniffed sideways, you pieced together the translation: *Mt. Airy, huh. You must think you some kinda cute. Yeah, West Side, huh. Everybody up there light, bright, damn near white. Everybody up there all siddity. Think you better than us.*

(2)

Housewife-cook. Construction foreman. Liquor store
manager. Children of. Office cleaner. Security guard.
Housewife-laundress. Children of. Steel mill worker.
Housewife-gofer. Office worker. Classroom aide. Children
of. Dry-cleaning delivery man. Would-be cocktail
waitress. Children of. Nurse. Clerk-typist. Letter carrier.
Mysterious suited business man. Children of. Failed
grocer. Housewife-nursemaid. Children of. Water company
worker. Teacher. Part-time jazz musician. Children of.
Ex-sharecropper. Part-time janitor. Part-time cabbie. School
bus driver. Housewife-chef. Tupperware saleswoman.
Temp bookkeeper. Disabled cabaret dancer. Had-been legal
secretary. Drugstore clerk. Children of.

(3)

No social maneuvers. No Greek-letter salutations. No
 politico nods and handshakes.
 Any deacons among the fathers? Maybe.

What were you doing there—among measured Gentiles
 and comfortable Jews, content
 at that suburb's waystation? Daring to savor slate roofs,
 flowering trees, demure stained-glass side windows?
 The nerve of you.

Nothing but a motley tribe with "common sense" for rules
 and a South that shadowed your home talk. Your habits
 and do-not-do's. Nothing but a South
 of troubled sleep you left on pillows by instinct
 when the days pulled you up.

What were you doing there, a tight-smiling, integrated mile
 below the segregated WASPs, gatekeeping
 Chestnut Hill, past the cautious boundaries?

Tricks and treats. Standing guard. Snowball wars. Sweeping
 streets. Organizing football.
 Tagging base, half-blind in twilight.

(4)

You brought ham hocks and other heavy spells. Nervous
 poses. Rituals designed to keep your brown
world inside its hems and creases. Inside
 its crossed arms, its benedictions,

inside its closed books, stashed in boxes. Under beds, under
 slips and stockings. Children of gargantuan
debt, older than your city. Older than the flag
 and that broken bell

they kept downtown. Children of hammers at dawn—
 the ding of them still radiant in your eyes. Of fully
human fields half-harvested, half-poisoned.
 Children of the ravenous

disinherited, riding the Pennsylvania Railroad,
 making a song of sound threads, landing
in the uncertain dark. Back-staired, side-alleyed, night-shifted.
 A world

that first came secondhand. One that you changed; you
 changed into something
particular. Wandering Carpenter's Woods. Running
 for trolleys. Swinging

from your Tarzan rope in Cresheim Driveway. Tipping
 your mouths open to snow or sun melting
over Sedgwick Playground. Whatever touched you had to feel
 your weight and know your wisdoms. Whatever

touched you had its place in your mosaic silences. A world, just
 by being. Your known shapes, fit together, made a subtle
science. A living art. Everything folded differently, ever after. Breathing.
Being. Who you were. Seeing. Breathing. A world you changed.

(5)

You caught sight of them across Lincoln Drive
in the back of a Caddy. Passing by.

Children of the faintly black. Folded up in that alien
quiet of the deep West Side: that well-fed lie about skin.

Heading to the store, you met their odd intensity. Eyes
cut to the Pepsi sign to dodge their downward glance.

Children of the loose curl, waves-without-heat, bleached
 to pose
for admiring. And not just yellow. A buttermilk rainbow

with rare glints of caramel or coffee; those were the kids
of Somebodies, you guessed, making them undeniably rich.

You rode the bus to high school with them, saw the gauntlet
on Ogontz Avenue begin: parked Firebirds and Vettes.

Invisible, you took it all in: the quiet barrier
 their practiced laughter
made. Some private doctor-lawyer ritual
 of a certain future.

You raised your eyes to them when kinky heads
 at last prevailed;
when an angry dark crowned. Angela Davis threw
 her fist, raised

Gil Scott-Heron's beautified shatter and those two
 brokered a treaty:
Ultimately, all of you were Black. Young. Gifted
 with a funk affinity.

You even partied with them—now and then,
 before cotillion;
a rhythm-truce Mandrill and War affirmed for that
 brief season.

(6)

On the porches—a cord run through a mail slot
to a record player—we lived our Motown.
Our Tamla, Stax, Gordy, Gamble, Chess,
Our Parliament, RCA, King,
Polydor, whatever else—played three-minute holidays.
Washed it, dried it,
wrung and hung it,
wore it into battle. Rolled up inside
our groove, we rode it home.
Harvested all seasons.
Drank treble. Sucked the bones
clean off the bass,
Juggleneck matched to a swung ass
no matter which body; every body
counted off James Brown.
Sculpted geometric spines
gathered to re-sanctify at the base of a tree.
Fire-slippin', camel-walkin'
on those cool family porches.
In living rooms with chairs pushed back
—bathroom better be wiped down!—
barbecue chips in the kitchen, cream sodas in the sink,
fingers sauntered to the Bridge, as sure on the air
as a 1-2 feeds a 3-4

We spun out to cross back
on the Scream, on continuous
head swill. Shoulder drill
skidded back and bopped
the broke-down walk, 'cause we
had it, owned it, ruled it:

Our collard greens cauldron
of funk horn religion
electrocuted and sweated
down to a trashcan cooler full of ice.

[LETTERS TO MT. AIRY, WEST SIDE]

240.

Women like these, you have never heard. Nurses
who swear no sacred oath, zipped into uniforms, riding

ripple-soled shoes. Peeled-up support hose and a towel
tucked in their belts. The only white things to cross
 their daily door.

Heat surgeons swerving hot tools and fat blots of pomade.
Those teeth flash. Those teeth bare. Glints negotiate.

Chewed ice teases a cold RC into a fight with a Pepsi.
Those hips reply to heavy riffs; carve hard polyester.

Greasy fingertips know where the garters go.
Those back-gate squints measure the street with a busy hand.

Uhhh-hmm. Mm, mm, mm—somethin' else, Girl.

Soul scientists, they know what buttons mean, halfway
up, dangling or closed. When dingy collars match

rank odors. Why awkward combinations ride
in churchy women's purses. Born at night—

but not last night. Know anything about
a man. How to trim and dress him. Lock him out.

Could teach you—if they chose, how to go
and get back home. Those mouths fit Mother,
Momma, Ma'am, and Mutha in one sentence.

Laughter like they cook it
 educates you in sounds
 almost worth the torture-turns
 of a press-n-curl:

 Thelma's whiskey-tinted bark
 Ernestine's cut-crystal gravy
 Della's slap-cackle
 Laughter like this must have another name:

 hot-water cornbread, stirred up gritty,
 chicken spitting hissy-fried,
 or breaded in a crush of seasonings
 greens that ain't got a recipe—

Watch their elegant arc: physical, vertical—
Whose new job, wedding day or prom be worth a damn
 without them?

Watch their elegant arc: cultural, chemical—
Eyeballing portions of yes and no. *JET* and newspapers too.

Watch their elegant arc: jovial, ministerial, entrepreneurial—
Near a thousand dollars in that apron pocket, no question.

Women like these, you have never smelled. Cigarette-
 &-barbecue chips
pin your front-yard breath to the sink while they push up

the blinds in their freest place on earth.
Uhhh-hmm. Mm, mm, mm—somethin' else, Girl.

[JONES BEAUTY SHOP]

189.

you dead
and frozen
dancers you
severed dreams
you fractious
fractured arms
you earthen
bodies dispersed
dispensed with for
new concrete barriers

[AMERICAN ODE]

23.

on my way somewhere else I
stepped into this mirror I
see everything multiplied my
eyes to the glass bowl of the world
feet testifying to ages
that came before my
head spinning young
voices the kind you hear
in celebration green as a cool
walk down a summer
street toward the sound
of your voice, brother
a razor humming

 the smooth silver clips
 of Billy Eckstine humming
 the smell of Friday nights
 as the daytime of me washes
 down the sink as if according
 to plan according
 to your voice, sister
 explaining it all

 in contralto measures
 from that solitary
 window your steadfast
 singing visited on us

you sister, leaving
your floral trace folded
in a Southern
way your beautiful
blues your years
of walking add up
to days on our street
your train of petals

 you, brother
 in the caramel leather
 chair at Pomona Street hands
 still in the barber's silver
 world hands free
 in lion-play your steps in time
 your music prying momentary
 strings up through tongues
 and jackets

[MULTIPLIED]

87.

Waves in your round, round
eyes melt down. Plinking whole notes
freeze. Windows in your
internal city pop out;
children chant as if on fire.

[EUNICE IN FLIGHT]

Your take-home pay is $
Your brake job ran you $ Followed
by $ to cover the
cake for the niece whose
father died of AIDS
a month before the cut-off
for ADC to help
such children. Her momma
ain't been seen in 3
years. Ain't called in 2. This
niece graduated from high
school. You know she's got a
friend going to college
and you know before her momma
left she got decent grades. Loved
math. So you pull
in quick at the Acme. Check
your balance again, knowing
before the digits print
that you'll exit the parking
lot with less than twenty
left in the account. Cable
bill may bounce but maybe
it won't catch at the bank
til Saturday. Maybe you'll have
it on through the weekend, long enough
to see that movie with the kids
where the bears—no, penguins—
dance across orange
and blue-white ice, giving them
something to sing about.

[EAST CHELTEN AVENUE]

300.

(1)

Most Christians would call you unwashed, but when 8.99 hyacinths curl under white tents in Target parking lots, you stir inside. At the sanctuary of a shady creek, you still get the joy of the morning.

(2)

Lent. No one ever said what it was for. Maybe they did and you were too candy-inclined to hear. Easter Bunny nonsense. Whatever. You just wanted Grandma to spot you across the sanctuary, to witness your recited mumble of the resurrection. You wanted her nod. Assurance that she would step down from the high pink hat to her tidy apron and Hershey-sweet brown arms, to a biscuit plate in motion, passing your way. Ham, mac-and-cheese: every year. Coconut rabbit cake on a jelly-bean platter: every year, under the buttery, elsewhere eyes of white Jesus. Cold Pepsi: every year.

(3)

That yellow Nehru coat you had to have in fifth grade. Stockings and some sort of heel. Every year, a longer tie on Ben. Vaseline directives. Easter duties spun your mother until the organ poured on us and dropped its holy veil. Hot-comb touch-ups, twirling from her tense arm and planted hip. With one shoulder tilted to the kitchen window, at least she could look down Weatham Street at a pink and lavender spring. At least she could hum something over the burning air.

(4)

Late morning, deep in a wooden seat: your time to feel the
knowledge behind all this. What sent such a lariat whipping
through the old-time eyes and cheeks and hat-tilt of Miss
Georgia Brown? What made them call out *"That's right!"*?
What pushed the old men to stamp those wooden feet?

(5)

Belting "He Lives, He Lives," you felt that high room lift
higher. The sound we made together washed the air. Joy was
real. Making all of the must-do's and have-to's more than
fakery.

(6)

You could be patted, pinched, and gazed on for inspection
by women—once girls who giggled with your mother. Those
fond hazes and floral hugs. Those strong country teeth. Those
sturdy eyes in small groups, untelling. Those buttoned gloves,
pressed to the neck or arm with meaning. Wanting to impress
them, you better have known when to speak up. When to
keep still. You could make admirers, or you could sink on a
fingertip.

(7)

Your time to let your heart out of its attic. Get someone to
see, if anyone would look, that you should have whatever
good God sent. And you could ask. That we were worth
whatever good God gave. No Sunday bombs. No queasy
quiet. No fire-spitting teachers. Or police. If this flower-song
miracle was a rescue ship, then everyone here got on. All of
us. No one drowning, no one falling behind.

(8)

Trumpet lilies pack the Acme produce section. Although you
never plan to, you take one home: every year. Lilies. Their
strange breath turns a private latch to a pink glass window.
Welcoming a bodiless Jesus back from death to sunshine and
purple, where the redeemer ascends the steps from a dank
church basement to a narrow brick house, homemade, where
somebody tried to love us all together.

[EASTER]

18.

You might drop the blue cone into a girl's top when she
reaches for Kool Aid if you are a boy. Stop the game. You
might sucker-smack the jokester if you are a girl. Go in
your bra, slow like he wants to, and pluck it. And on goes

Parcheesi for street siblings, a marathon of sad
heat. You are a string of jangling ages. Knots. Secrets. Only
four per round can play. Watching, for most, strangely
okay. Two on the wild fringe of boredom scrounge

up quarters. Take a dare to cross the tracks. Make
a deli run to Sam's for hoagies, pineapple soda—
the new thing, and a large birch beer. Your oldest girl
performs the miracle: divvy the pieces, so everybody

eats. The after-ice from Kool-Aid in Dixie cups
suffices to quench. Each of You cross the street
to Durand or hop the Weatham porch walls home
to use your own bathrooms. All of You sprint

back. Bringing baggies-full of something pinched
to complement the munch. Readying a story
you can rise to, so when *who the hell ate a pound
of peaches* comes, your answer feels easy as sweat,

less like a lie. Wasn't that the Curtis Mayfield
summer, too hot for church, three weeks straight,
when a mother reported seeing 16 kids or more— every
one of You, clustered on the Kincaids' cool stone

porch? Didn't hours of contest color the air?
2:00 Winner plays 4:30 Loser. One of You takes
deejay. Another shuffles 45's. Rebirthing
a Best of B-sides sing-along. Some of You pick

scabs. Croon into folded arms. Accent shapely
hips and hands with feet. Content to be quietly ignored
and included, confused little sisters coo like sleeping
butterflies by the steps. Squat to snatch up jacks. Sprawl

on nubby cement. Sweating, strategizing, biting
ice, none of You lift a head. None of You have jobs
yet. Isn't it the summer before Neighborhood
Youth Corps? Just before fast-food counters

crowned most of You speed waiters, change
makers, and deep-fry men? Something that started
already after someone shot Dr. King, tilts now. Rips
down when Fred lopes by without his 'fro— he signed

up for Viet Nam. Apologetic eyes taking in all
of You, looking up to the porch. You pile into this hulk
of chiming changing flesh. Fixating on the board. No
one moves until the dinner calls fly twice. Until

night floods, indigo. Porch lights lure the moths.
Gang wars quake too close on the Avenue. None of You
ready to name this peace You cling to. Unready
to unfold your fist in a nest of Parcheesi. And go home.

[6966 WEATHAM STREET, 1968]

184.

(1)

Voyagers. Bounding into your adult bodies with no direct
protocols for terror, only the commonsense boundaries of
your place in time: steer clear of the blue-collar whites—
Kensington, deep South Philly, the Northeast; watch your
step in The Bottom; mind the borders of Cobbs Creek and
Hunting Park, 9th Street. Make sure to send your
mortarboard—white satin, royal blue, G-town green— sailing
in the air, and catch it.

You know about that atomic warning spiral, rehearsing you
to die folded, underneath your desk, head covered by
your coat. You know about contraband, visible or not. Ivory
soap and Posner's and discreet safety pins. How to fall asleep
on the bus without missing your stop. You recognize threats
of strange undoing. Swift marriages. Pills and rumors. Rage
seeping out, wetting all rituals, all smiles. Rules riffing.

(2)

Fliers. Throwing back your heads on the train platform, star
children bound for New York, you party on the brink
of a coming year. Metallic jeans, flamingo satin,
rhinestone-embedded, leather-embossed. Shoes so outrageous
you will cringe, asking later what drugs propelled you
into snowstorms on velvet platforms. Watch Night, when
you sat hungry, protected in the pews, or banged on pots
at home, straining to feel new—all that
is a fast-blurring memory.

Stevie Wonder isn't little anymore. Grew up, got fine. Left
home and took his poems, so why not you. Another world
seems to echo this question. It runs hot fingers over your
sex. Wet as that mystic sheen over Market Street.
Difficult to see by glassy stars, that limitless world you lean
into reads your tender body backward.

(3)

Saviors. Barreling into Thanksgiving dinner late, on your way
to a homecoming game. Feeding a ritual that feeds you.
Brimming youth or style or college credits earns you a local
stardom at this address: you are the newspaper of Now.
No buckets of water or slop. No chickens to feed, pet, or
slaughter. No barriers to pencils or lights; you're born
expectant. Deaf to dawn's ringing hammers.

In flight from a language you speak but won't own. You
stutter briefly before those creaky eyes, gone black
as a country sky. With fingertips ignorant to the Earth,
the codes and textures they lived by, you pull away
from the table, carrying plates. Leaking from the stack,
some ache only Aretha can contain.

(4)

Collectors. Climbing the front stairs to the ballroom.
On the outside of platter and mop. Above
the boiler, out the pantry. Ununiformed. Sometimes.
Under contract to Jesus and Yemanja. Allah and Avon
and MaryKay. Governments and social mandates. You
might show up anywhere. Suburbs. Cubicles. Taxicabs.
Fleeing the Rusty Nail Tavern or renting a stool. Nod,
dap, handshake, squeeze—you get in where you fit in.

You know how to talk shit to doormen. You recognize
redcaps. Greet housekeepers. Tip cash. You know
what looks too Black. How to renovate smiles.
When you knock at a homecoming door, they watch
from some Southern county they will always wake up
inside. They peer through the screen. Brighten. Raising
a hand or foot to trumpet the joy that leaps from their
bandages. Something worked out right, for all
their secret trials.

(5)

Wherever you enter, your ancestors
catch a swallow of wind and exhale
an ever-swelling cloud
of silent molecules called prayer.

(6)

The food that raised you
clings. Staples of another country
you cannot see. A country
you recognize by smell
and inflection. Corn pudding,
mustard greens. Rutabaga, candied
sweets seem to call for hands
you have let go of. Food your mind
retrieves from the wreckage
of row house dining rooms, scalloped
paper plates on an Oak Lane
sun porch. Undulating arms, anywhere
across a loaded table, greet
you, prodigal, at first fork-kiss.

(7)

You will ride all night, collecting dares and decisions
 concoct games of illusion and risk, renamed as romance

You will watch your parents watch you
 take to varying levels of uncharted air

You will rage at their grim country metaphors and tropes
 notice their inhaled sexlessness, girdled faith

In their midst, you will prowl for a window to prod, a door
 to tease escape
 trail their rutted steps at uneasy distance

Bludgeoned by their ripe imaginations
 long-divided by their debts

Into cars, into rooms, constant at the elbow you begin
 to follow, and tape your address to the wall
 beside the landline

(8)

Cackling and weeping beside his mother's
grave, one of you says "We're at the front
of the line now, Yall—" and everyone stares
at the flutter of their open clothes, cut
where his words impart steel: lilies, coral
and canary, flaunt their gorgeous lie
where his words mock your scant recoil: silver bars
brace the rectangular hole, unveiling naked fear.

Now that the elders have trailed the breath
of stars, the ones who scrimped those tickets,
rode those trains—into, through, under—hollowed cities
their bodies submitted to Wars and wars
to change forever what now seems erased, you,
and only you, can see that portal.

[LETTERS TO THE FIRST-GEN NORTH]

DANCING ON
THE SHORE

329.

Can TV redeem
your skin? Chart, lean, sail til brown
Hawaiians wave you
Ashore. Zorro revives Black
Spain. Curls. Your Mexican past.

[NO WAY THE WHOLE WORLD IS WHITE.]

66.

The World sleeps. Behind
silky animal teeth. You
blink. Seek. Call the green
sky down. You plow magazines
to stare yourself into sight.

[*HOLIDAY* MAGAZINE ON THE SOFA]

67.

In the summer of Shing-a-ling and baby blue,
culottes and French twist, you are a student
of the social arts, in training for cute.
Measuring how well your short nose
and heavy lips present under a dim blue bulb.

Slice your bangs with three fingers, practice
Smiling. Do something with those undainty
hands. Chips and dip on a napkin
but not *too* prissy. Make the drink
last; let your eyes climb the cup to the edge.

Now here come the fellas, tumbling
down linoleum steps, magnetic
in pressed white shirts and creamy
sweaters, beautifully foreign, dark
necks like spice jars, opened.

Toothpicks winking and tilting those
half-smiles—dangerous veils. Who
knows what they'll do. Test your skirt
for tightness; will it give too much?
On a fast song, browse; flip records
while you jiggle the butt to make
up for what's lacking in your face.

On Smokey's cue, the fellas launch
from their dark harbor like a fleet
of new ships. Quick: hack the frozen space
in your throat. Cute demands an unwrapped
tongue, sprinkling bright remarks. A cache of candy.

Tease your earrings, cool your eyes while the fellas
cruise, sit without sinking, amused
on the edge of the couch. No sorry vibe
to anyone. Keep moving, dance a little on your
own in case nobody taps your hand.

["WHAT DOES IT TAKE (TO WIN YOUR LOVE)?"]

311.

No blood-magic flair,
no hidden Puerto Rican
grandmas. No Bajan
aunties, lilting crowded rooms
with fried cod and ginger beer.

[JUST AMERICAN KIDS]

345.

When Sonia Sanchez wrote "there is no place/ for a soft/
 black/ woman," I began
to mouth the words you sang, obvious and true, smashing
 the surface of lies I had already
known on sight. Recoils and curled lips. All the slivers.
 Instead of bowing to the scallop
of jewels in your upswept braids, my father sneered at you
 on TV. Only able to retch a blind and idle
ignorance at the actual sight of a Queen. I
 forgave him; how else could he
say the storm of you snatched the brittle armor off
 his unrelenting pain? Every shade of your country story
undulating hard sun. The multiplied
 breath of souls, dismissed as steam after rain
by the foolish or fearful. Every cloud
 of our Southern exile passing
through shimmering fields, human tolls
 absorbed by trees. On a ratcheting, dutiful train
that sweeps by Gordon Parks, crouching
 in the rows, his third eye blinking.
Every wrenched heart riding
 to its Northern answer.
Banging out of that piano. Your truth-transfusion
 surged into places awaiting your
arrival, like wartime's aching faces along a liberated route,
 like feverish arms open to uproar, like
witnesses to terror, testifying. "You are young,
 gifted, and Black," sailed up my spine. My thick
mouth, used to the smack-shut of ugly,
 began to sing.

[LETTER TO NINA SIMONE]

344.

You smoke on the back steps
under a nook of trees, or in a darkened car,
halfway down Livezey Lane.
With that teenaged girl's bong of a room
at the roof of the house? Well,
of course, you wedge the staircase door
against its tight jamb and towel-seal
the one up top. You crank the 3rd floor

window out toward night
like the single, rickety wing
of a half-built space ship. And blaze.
You take to keeping matches
in make-up bags. A better brand
of rolling paper lines your wallet.
Roach clip on your key ring.

Cannon-shot into a world
where the ordinary transforms,
you see parents turn more
human every day. Reggae
slides in by a side door: handsome,
slender, and spicy-Black.

Rough hair brands the sweet-once
skin of boys. Hints of what
some girls know
swells, harder to hide. One
war seeps out on TV, unwilling
to stop or pretend.

Torn polyester nightgowns turn up
in your dreams. Left wet
on clotheslines, they look like all
the mothers' faces, under their smiles.
You smell gristle in the fathers' tire tracks.

Any angry fraction of a day
might send your life peeling
like a tarp under modest wind,
curling into limitless sky.
So you keep toking. Spinning like
that wheel of fortune old people
play on their TVs. Finding
reasons to tip the floor, to charm
the sprawling air and give chase
to fat-roach weekends, giggling too
hard to finish more than half.

"This is a joint. A joint, a joint,
a joint." Cannabis in the sunshine
cues up that Roy Ayers
tune: an incantation.
Cannabis gives you solidarity,
mundane, momentary,
and grand, in the dented circle
of souls who would let you
in. And isn't it time
you laughed? Among delicate
wrists and hulking shoulders,

local stars and actual debutantes,
even with a nose-ringed white girl Brian
brings around the corner only once,
you puff and pass. You toke at the train
station. Comforted by a lit stick, small
as a pinkie finger. Hardly as thick.
Or so it seems, it seems, it seems.

[CANNABIS]

321.

Jimi on Dick Cavett's show got your full attention, in girly
hot-funk finery and a mustache. You recognized the cobalt
halo, the aqua boots of a weary prince. Sapphire sweat,
beading his Southern ax. Roping the neck of his six-string.
Lighting a down home track in his elsewhere way. But his
how and his who—a tangle, traveling in his stowaway heart.
Invisible thread. Amusement park logic. An accent that
couldn't possibly compute. Blues was a gut bucket, the old
women said; did that explain why his free didn't seem free?
An overhang, somehow, rimming, despite his orange. Under
that fried, desperate hair, his needing. Despite the brocade
patches lining his pockets. White handprints all over him.
White in the creases of his mouth. Nobody to tell him he was
ashy. His train whistle, circling. His train whistle, calling out
names. His train whistling, so far off.

[HENDRIX, ONCE]

19.

Up in the bedroom, brushing and humming. Combing
 and crooning. Liking yourself before digital
inventions of damage. No need to fold
 your spirit into origami, wondering
what strangers will approve. No need to make
 of yourself a paper kite, sailed into a thunderstorm.

Out at the bus stop, after school. Noticing
 choreography between engine and air, feet
and wheels. Timing who moves, who
 fades. Yellow to Red
to Green. Who scrapes the corner, laughing,
 who runs to listen, who flies.

How your bangs comb out sparks each day's
 happiness. Double-dutching in plaid
jumpers and knee socks. Running through sprinklers, those
 birdlike fingers foretell fringe. Smoke is not a bad
thing; only a messenger, carrying a nomad language. Words
 the hawk-wind peels to write you letters.

Girls are not always a good thing. Setting traps
 on the schoolyard wall, under the sink,
outside the gym. Spitting nail-file bulletins
 in bathroom stalls. Jealous of your ring that opens
on a hinge. Stuffed inside, a vocabulary of shrieks
 and clickity laughs you use to wear girls down.

Snug in the arm of a tree sturdy as a wooden shoulder,
 you're unsure how you climbed, how you'll land
again. Up there, steadily cooler tears trace a new ritual,
 from plummet to plumage. Up there, your shining pulse

tells when to tip back your head. Who left a nest of notes
 for you to season and stir? When you swing down—
meaning more than breathing—
 another world blazes, ready for its name.

Cobalt to Yellow, reeling. Seed-green
 to Magenta to Star-white. Drum, waiting
for what you got, you got. Louder
 time, time, ain't no time for waiting
to do. What you got, you got, getting
 louder, loud as a moon, expanding.

Boys are not always a bad thing. Not when you know
 how to make them your brothers.
Not when being a very small girl teaches you to read
 for flickers. Pinochle, pancakes, rose thorns,
maps made of cramp and ache, parallel hallways.
 How stupid they can become, looking
down at you; how mistaken.

What would you call it—ray, ladder, creek,
 channel, path, shower, beam—? Nameless
world, sighting you from train bridges, from sycamores,
 from low clouds when the lake
looks like a chewed patch of gum. When golden panes
 make church from a factory.

Portal when you close those votive eyes. Prism when you open.

[SET FOR CHAKA KHAN: YVETTE]

incense kite or mandolin
tower climbs to diadem

where your voice—
scrolls. turquoise and chiming

palisades, turquoise, blaze.
(*how, did it spring*) (*howdiditspring*)
. . .
minarets and mesas vow
prisms glide so aerial

born, your voice—
trance. fuchsia and reeling

redolent mistral, twirl
(*every harp-seed*) (*every green key*)
. . .
banquet cloud or palanquin
tidal sails to dazzle wind

fly your voice—
scarf. migrating mingling

primeval palette, haze
(*rebel blessing*) (*blessedsound*)

You: tether languor, anchor sublime.
Votive nomadic. Radiantsoul.
Votive electric. Quetzal blade.
You Magnify. Magnify sky, You.

[SET FOR CHAKA KHAN: CHIME]

273.

With a needle
set down on a bass
a balafon, a chekere,
a saxophone, WDAS-FM
dismantles your poor
cage of a mind; now
it's a fuchsia colander
and Pharoah Sanders
will lead the rinse
of it, pouring one
window-open
morning. Gold
you hear. Gold
you crave. "Thembi"
transforms a grimy
street and someone—
call-responsive—comes
out to sweep. When
have people like You
had room to exult? To stand
in daily power, finding your skin
resplendent? The claim of a New
Thing coating your hands?

[WDAS-FM, 1977]

215.

Culture-fest with a side of track and field and your mission: Scan
for a certain sort of Man; observe, observe, observe.

Among bistros, bookstores, stratospheric dorms, you are less
than a bird. You jaywalk 34th and Walnut traffic, not directionless,

but lost. Among all the Black collegiate cool you scheme to draw
into being, two fine fella-winks and three nods ain't enuf to get

party intel. When the race gun pops, no one to root for. No ties
to Greek tribes, but incense clouds outside the gate suggest a better

festival. Drums catch and steer your hips, so take an easy target:
flirt with the vendors, all luscious locs and Brooklyn
 accents, turning liquid

eyes to profit. Silver clamps their onyx wrists, tiger's eye rings
contour their carpenter hands, raw turquoise swinging from necks

savory as poems. Fall in love twelve times. In two lip-glossed hours
of browsing, you've married three of them in six-minute

ceremonies. All of them scented and marked, of course, by some
rice-steaming Crown Heights sisters. You see that flutter. Even

with the sexy pivot of their Army fatigues, the float of toddler
handprints mark the way they dap and grin, arranging wares

and unloading their vans. With a high wave, you divorce each
one, and break your dry delirium. Come away with new

earrings. Soak up these trinkets of Blackness and twirl
in incense-and-leather, this ideal of a Black velvet

world. At least you're young, you're off the porch. Out
in the street, free dreaming. Striving for fly.

[PENN RELAYS]

212.

Did you sit by bus windows, your glance
full of eyes brown as beer bottles. Brown
eyes, salted with ugly indifference, inexplicable
eyes, brown as untainted

coffee, milkless caramel? Feel the slaps of a pair hungrier
than muted vows, smothered pleas, spells
unlearned, haunted to know why we love, why we

still manage to love? Were you quick to detect
circumstance: who has an out-of-town
jawline, a safety pin in her panties? Brown
half-open eyes, flat

as unshoveled turf, catch your glimpse. Share
the nod. Their flame and clamor raking in ads that grind
their gifts down to $7.99. Sharpening laughter to a vicious

need. Did you all but swallow the sax? Did you
foresee our curve toward insight
and madness, kufis and geles, Jupiter
and Mecca? Questions of ratio—African

where to American what, Diasporic how
and when? Were you witness to children on subways
who strain to lift their parents' unraveling eyes, unsure

of who to save, or how? Did you sit
under a sandalwood rain, inhale myrrh, intone
an om, occasional or weary, that liquefied
your Southern lintels? As liquid,

did you travel horizontal? As turquoise, magenta, wild
laguna, every cell a sound, did you burnish green
to golden? Then pour yourself back into your human

mission? Sound carpenter. You know what waiting
and wailing is, bowls overfull
and overturning. Blanket weaver for our shoulders, our

ever-yearning shoulders. Or did you just press keys?
Knowing salvation would sweeten
and brass would bleed, somewhere on our journeys?

[SET FOR PHAROAH SANDERS: BUS RIDE]

Gold

Gold you glaze
 dry our sorrows
Gold we crave
 dull the arrows

Golden horn
 water crossings
Golden horn
 claim our losses

Gold restores
 human ashes

Gold you pour
 through our madness

Gold within Gold begins Gold our skin

[SET FOR PHAROAH SANDERS: CHANT]

174.

A vendor at Penn Relays hands you the portal
in a plastic sleeve: five brown cones. Your first dose
billows out inside the world of Watu's car, a scent
that claims the power to melt. Set that pyramid
gladly on fire. Let it flicker. Let it smoke. Gold
and fuchsia, painted like a desert, glaze your nostrils,
blush your walls. A new room, cloudlike
orange, assembles in your chest. Your bamboo
blinds widening to slashes you can climb
through. Mind turned nomadic, you begin to believe
in fringes. Tassels. Brass jugs. Visualize return
to a past you're unable to remember. Oceans
call you to a Spanish portico. Tiled arches.
Even India. Carved doors of wooden lace, oil-rubbed
and sweetened. A firm and loving feeling underfoot.
Sandalwood lifts your hands to release a way
of living you can imagine. No nappy shame. No
excuses, rinsed or mute. This satin cushion, incense
or oil, buffered by mystic rush. Carry the measure
of this moment. Traveling. Now you begin traveling.

[ODE TO SANDALWOOD]

Definitely your mother, surely your father, too, warned
about women like us. Though we showed signs
of training, we weren't pearl

enough. They could read on us the shadings
of our cast-iron stamp: Georgia-skillet-and-God.
Though we were only would-be women then. After

all, could we affirm your footing? Fuel your upward
aim? Would we carry off the language?
We might not make the necessary tilts

toward your white associates. Or drop that Too-Many
attitude. Wearing the wrong shoes. Wigs, even. Loud
friends. We might appear to clutch

at Money. Our minds and asses, over-packed,
could not be girdled properly or trusted
to tepid nods. Even educated, we got in nameless

and unshod. Our degrees somehow bear
a backward scrawl; easily angered, we might
simmer a pot of Nella Larsen, and splash you

with the sauce. Okay, some youthful
half-buzzed rubbing at a disco, but no congress. No
room to retreat from rules you learned

at the Cape, the dining table. The ski
club. So when mutuals introduce any of us
to any of you, your eyes jigsaw. All formulas

for what your golden equals
lack such scenes. You would have to dare
sit down, plain. You would have to skirt

the guidelines for laughter. And lips. So
you freeze. Try to assemble
a mosaic smile in a mouthful of refusal.

We cut our eyes toward practiced laughter
by the pool. We fold your shuddering up
in a cocktail napkin. We swill our glittering drinks.

[ASSIMILATION]

302.

you fresh
 and waiting
 dancers
 stroked believers
 you flushing
 hopeful private parts
 you elegant
 testaments, cautioned
 insufficiently for
 slick urban renewals

[AMERICAN INNOCENTS]

312.

These days in Chestnut Hill, Black folk move unalarmed
among millionaires. Easy, without permits. Stand
ahead of them in line and who knows, some might sip
versions of that comforted air. No uniforms at back-door

screens. Likewise, we stand, in May. That cage-door
-open month, that giddy sprig of professorial joy, makes
comrades out of two faint pals. Choosing
raucous, we luxuriate in catching-up at a sunny

corner, to reward this often-lonely haul of living
so when one White lady curls her head, owl-like—
shoulder a dim-witted blade of disgust—we
merry. We ready. She gon make a show of yanking off her

purse, and knotting it to a football, to pack a practiced
tuck. Setting up the blitz with a hard swipe
of shade, she runs a play that takes four dashes
from the cheese shop, bearing down on two writers

(rowdy now) holding (rather slender) court with space
allowed (sentries, as ever) for passersby. Our poor
bodies buckle unprepared (yet, ever ready) for tsunami
laughter. Think of our rolling eyes, tears out

our pores. Our wordless whoop sets off a waddle—maybe
balloons, yeah? Parade-size—Bert Williams, Moms Mabley,
Roy Wood Jr. They swell through us and overtake the air
above our heads; we can't fill up fast enough. Our May

sky changes to a slow-motion chuff, spewing a popcorn
giggle storm. Knee-sinking speed-puffing hand
slaps. Chest-bumping shrieks and hollerlujahs dart
up and burst those Black balloons to knives. Sparrow

murmuration nets, spirit-writing on these Black
bards. All the battered organs dipped in broken teeth,
in torches. All the bullet holes and beaten curses,
left in the sizzling ruins of rope, writhing
every word, crushing every withered leaf

fallen from the Tree of Life, convert to an ink
that hexes. Nixes every innocent claim, every
consecrated theft from killers, every lie compounded
by naïve bleach. We released only a few

of them. No; more—for what would she have
done if we shapeshifted to them Blackbirds
who wouldn't hesitate to bust out the pie
she half-baked, step up red-gummed, and breathe

all down her manufactured jungle? *No ravage-fantasy, Missy.*
Naw. Just us. Her coins survived two writers, savoring
the momentary roll and crack of crust. You and I.

[LAUGHING WITH DON BELTON]

78.

Reggae your savior
Reggae your kinky reconstruction yeah
Spread arms, spread eyesight
Ride on the knowledge
where your thought begins

soak in this journey to audacity
your transformation
needs a Third World party

Reggae your passport
Reggae electrify the broken door
Reggae gonna change ya
Free up your joy self, dancin yeah
Dancin on the shore

[STEEL PULSE SINGS ME A DREAM-LETTER]

304.

Here we are, Love, eating nasty pizza
near the Trevi Fountain. Remember?
 Those Black students from J.C. Smith. All twelve, clustered
 at the window. Waving. Sending in an emissary. They fumble
 forward in twos and threes. Pensive smiles, weaving

through a love line. We drag chairs, we double our table. We
make a family moment from The Nod. Squeezing away
 a few homesick tears. Trading names, talking
 majors, taking exuberant hugs, we become
 Diaspora Uncle and Auntie.

Born between Langston and Baldwin, at the gates of our yards
 we meet Brooks, wielding a blade. Hurston clicking a gun
 in her purse.
 At the curb of the world, on trains,
 on buses, on planes, Cesaire
 and Damas become our crossing guards.

 We count brown. We regard gawks
 with even gazes; we dispatch with an eyebrow.

Here we are, outside of American myth. Unseen
until surveilled. Affiliated
 witnesses, bilingual pioneers. Born
 to cabbies and domestics, Avon ladies
 and janitors. Unimaginable, hard-wished. We
 build between frequencies.

Not that there's no fun in it. You tug my $5.00 scarf
from the African vendors, laughing while I reprise
 my tigress maul of Mr. Mini-Mart, once fool enough
 to stop our seven-year-old at the door: "Hey, kid.
 You didn't pay for that."

Counting the money of countries stamped with rebels
 or colonizers, we
field the same claim: whose worth is welcome.
 Patronize street vendors. Tip ritually, splendidly, always
 decent: doorman, hostess, concierge,
 towel teens, the friendly valet

 and always, always, Housekeeping: women we know
 at leaning-over-a-sink proximity.

Our mission finds us, doesn't it, Love, as we
find ourselves. Strolling as we do, You and I,
 into the Parker-Meridien. Gliding to the far bank
 of elevators. Aimed at the upper suites, we
 entertain a ritual game

of Whiplash Whitey: so much tamer than what weighed
our ancestors down and singed their veins.
 And between the button and the ping, here comes she
 who must make sense of us: a woman inserts herself
 (the twitch that never questions, dries, or pauses) to insist:

I *must* be Alice Walker.

Oxford, Rome, or Myrtle Beach, Cape Cod
 or Treasure Island, we take
no colorblind oath. Translate
no side-eye, balm
no afflicted curiosities. Sell
no magical Negro touchstones, carry
no ablutions, plump
no immigrant lie. We wear
what we know
into the world we have seen. Hail
no America we haven't paid for.

[YOU DIDN'T PAY FOR THAT]

122.

Your people made the great lunge
across unfamiliar names and gazes,
from a language they did not read.
Carved six-sided dice to better fit
their odds and country lives, clean
and pressed in place. That Maryland
lake where the tracks
seemed to roll on water
stood in for the Atlantic, another
midnight enormity, yielding no certain
grasp. In the dark, they frayed the name
of their One True Friend—*Jesus,*
Jesus—who spoke to that lapping black
water until they crossed. Until light
sliced the train car, butterlike. Dim
with crusty mouths and cricket-dream,
they heard the man call, "Next Stop Baltimore.
. . . Baltimore Next." But you?

You're a migrant, too. Like a high-stakes
traveler, you have also leaped. Train
decks, electric doors, odd-flushing toilets,
docks. High mesas. Sprawling piers,
left-handed cabs and Tube station
stairs meant to murder. You half-doze
watchfully, in unheated terminals
big as some towns. Waking up
again to stifled need, to "vanished
rooms." Over-packed containers
sag beside you, holding
intangible trinkets. Scraps
from your dream-speech. And you?

The one pushed forward. Hired
to demonstrate the outcome
of waiting in line. Translator
of languages spoken by the lost. Look

at your almost tireless, quiet
song. Keeping time. Pouring
pots of boiling witness
on flesh-eating crawlers. Trying out
clean versions of a tattered
name. Strokes tell
a one-finger trace
to half-legible ink:
your blues address, writing itself.

[MIGRATION LETTER]

NOTES

The section headings quote or approximate titles from the following poets, with deep appreciation:

"The Idea of Ancestry" from *Poems from Prison* by Etheridge Knight

"An Agony. As Now." from *SOS: Poems, 1961–2013* by Amiri Baraka

"That We Head Towards" from *Moving Deep* by Stephany (Fuller)

"Homecoming" from *homecoming* by Sonia Sanchez

"Dancing on the Shore" from *We Speak As Liberators: Young Black Poets* (anthology) by Al Young

"205. [Not Your Philadelphia: August, 1964]":
James Chaney, Andrew Goodman, and Michael Schwerner were murdered in Philadelphia, Mississippi, on June 21, 1964, while working in support of Black voting rights. Their bodies were discovered on August 4, 1964.

"74. [16th & Erie]":
"OIC" refers to Opportunities Industrialization Center, a training initiative founded by Rev. Leon Sullivan and

based in North Philadelphia, then a predominantly Black, working-class area.

"109. [Great Migration Pentimento]":

"The Great Migration" is a term that describes the process that saw African American Black people leave US Southern states for cities in the North, Midwest, and West in multiple waves throughout the twentieth century.

"111. [Letters to Black Bodies: 'Fence Walk']":

was released on the 1973 LP *Composite Truth*, by Mandrill.

"109. [Great Migration Pentimento: Jo]":

Black folk conferred the nickname "Chicken Bone Beach" on the part of Atlantic City's beach to which they were restricted in the mid-twentieth century.

"109. [Great Migration Pentimento: siddity]":

The website urbandictionary.com defines the vernacular adjective "siddity" as "uppity, pretentious, stuck-up, conceited. Acting as if you are better than someone else. To put on airs." This term also appears in part 1 of the poem "233. [Letters to Mt. Airy, West Side]."

"233. [Letter to Mt. Airy, West Side]":

The epigraph in part 1 quotes Phyllis Palmer's review of *Making Good Neighbors: Civil Rights, Liberalism, and Integration in Postwar Philadelphia* by Abigail Perkiss.

"117. [East Chelten Avenue]":

The acronym "ADC" refers to Aid to Dependent Children, once a federal grant program.

"67. ['What Does It Take (To Win Your Love)?']":

This poem takes its textual title from a song by Junior Walker and The All-Stars.

"345. [Letter to Nina Simone]":

The line attributed to Sonia Sanchez comes from her poem "Present," which appears in *I've Been A Woman: New and Selected Poems*. The excerpted lyric, "You are young, gifted, and Black," comes from a song composed by Nina Simone, "To Be Young, Gifted, and Black," and released on the 1970 LP *Black Gold*.

"223. [assimilation]":

Nella Larsen wrote novels exploring issues of African American colorism and class that first gained prominence during the Harlem Renaissance of the 1920s.

"312. [Laughing with Don Belton]":

Don Belton (1956–2009) was an American novelist, editor, and professor.

"122. [Migration Letter]":

The phrase "vanished rooms" comes from the poem "Elegies for Paradise Valley" by Robert Hayden, from *Collected Poems*.

ACKNOWLEDGMENTS

Thanks and appreciation to the following publications, in which versions of these poems have appeared:

"102. [Far]": *Poet Lore*

"50. [Migration Letter]" and "70. [white lie]": *SHIRLEY: Part of a Problem* (chaplet anthology), Belladonna Collective

"27. [night shift/day shift]": *Birthmarks* by M. Nzadi Keita, Nightshade Press

"45 [Libations for the One Hundred Years of Gwendolyn Brooks]": *We Real Cool: Philadelphia Celebrates Gwendolyn Brooks* (anthology), Moonstone Press

"173. [Migration Letter]": *Poetry Ink: The 20th Anniversary Anthology,* Moonstone Press

"69. [Mentor as a young woman: tankas for Sonia Sanchez]": *". . . It'll Come. Like the Rain Fallin' from the Heavens. It'll Come": A Tribute to Sonia Sanchez* (anthology), Moonstone Press

"9. [Letter to the Soul Singers]": *Obsidian,* 49.1

"11. [The Hansberry Suite: Afterword for Ruth]": *Obsidian,* 49.1

"109. [Great Migration Pentimento: Jo]": *The Killens Review of Arts and Letters*

"213. [Letter to Melvin Butler, 1965]": *Obsidian,* 49.1

"240. [Jones Beauty Studio]": *For Women Revisited: In Tribute to Nina Simone,* Debra Powell-Wright, independent publisher

GRATITUDE

This collection began as a daily writing challenge, with each installment given a number. Across several years, travels, pivots, submissions, mutations, and an unspeakable tragedy, this book made its own migration. For emotional support, insights, opportunities to test the work, encouragement of all sorts, good meals, and loving care throughout the journey, the following people, and anyone I have overlooked, have my boundless gratitude:

Chiji Akoma, Herman Beavers, Andrea Bloomgarden, Jodi Bolz, Ellen Bonds, Jackie Broomer, Ramona Broomer, Kathy Broomer-Parsons, Denise Brown, Karen Clemente, Margie Connor, Rachel J. Daniel, Genevieve Deleon, Courtney DuChene, Brendah Eady, Melissa Hamilton, Theodore Harris, Ashley Henderson, J. P. Howard, Becky Jaroff, Jacqueline Johnson, Bryanna Jones, Meta D. Jones, Kasey Jueds, Betti Kahn, Raina J. Leon, Patricia A. Lott, Crystal Lucky, the Ma Family, Trapeta Mayson, Barbara McCauley, Kara McShane, E. Ethelbert Miller, Terri Nance, Terri Ofori, Ed Onaci, Jeannine Osayande, Paula Paul, Aaren Yeatts Perry, Debra Powell-Wright, Karina Puente, Larry Robin, Danny Romero, Morani Sanchez, Mungu Sanchez, Sonia Sanchez, Xochitl Shuru, Taije Silverman, Carrie Simpson, Karen Smith, Patricia Smith, Carla Spataro, J.C. Todd, Edgar Torres and Brooklyn Gutierrez-Torres, Amanda Turcios,

Solana Warner, Nancy White, Robert Whitehead, Stacia Wilkins, Yolanda Wisher, and Codi Yhap.

Throughout life and memory, I am thankful for the families of our Durand-Weatham-Gorgas-Cresheim-Mt. Pleasant-Sedgwick village, and for Michael Coston's appeal to "write about us," when we once crossed paths in the post office.

Extra dollops of gratitude and love go out to Kervin A. Sims, the Presley-Dougherty Squad, Rachel Greenberg, Claire Phelps, Miyoshi Smith, Jaci Jones LaMon, Nathalie Anderson, and Lamont B. Steptoe.

A special kind of thanks goes to Nicole-Ann Bales Keyton, whose sensitivity, firm, friendly guidance, and keen attention have been indispensable to the development of this book.

Everyone at Beacon Press involved in the birth of this book has been welcoming, respectful, and supportive. A sincere thank you also goes to Helene Atwan, Marcy Barnes, Amy Caldwell, Frankie Karnedy, Susan Lumenello, and Priyanka Ray.

I carry ongoing gratitude to these larger circles of support for providing me with uninterrupted time, funding, technical help, and/or collective cheer:

Ursinus College English and History Departments, Ursinus College Faculty and Staff, especially Rick Kohn, Joe Trump, and Evie Miller in Tech Support; Yaddo Artists Center; Abby McGrath of Renaissance House Writers' Retreat and the August, 2018 Sisters of the Fork; Carlie Hoffman and all other poets in her 2021 Brooklyn Poets' workshop, "The Excruciating"; the Cave Canem Family; Pew Center for the Arts; the Furious Flower Poetry Center; Leeway Foundation; and Word Works Press.